WASHOE COUNTY LIBRARY

3 1235 03136 2796

P9-DWP-589

OCT 17 2006

DRAW LIKE DA VINCI

Susan Dorothea White

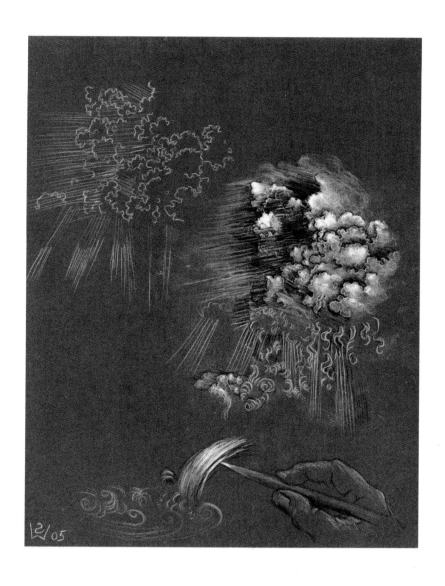

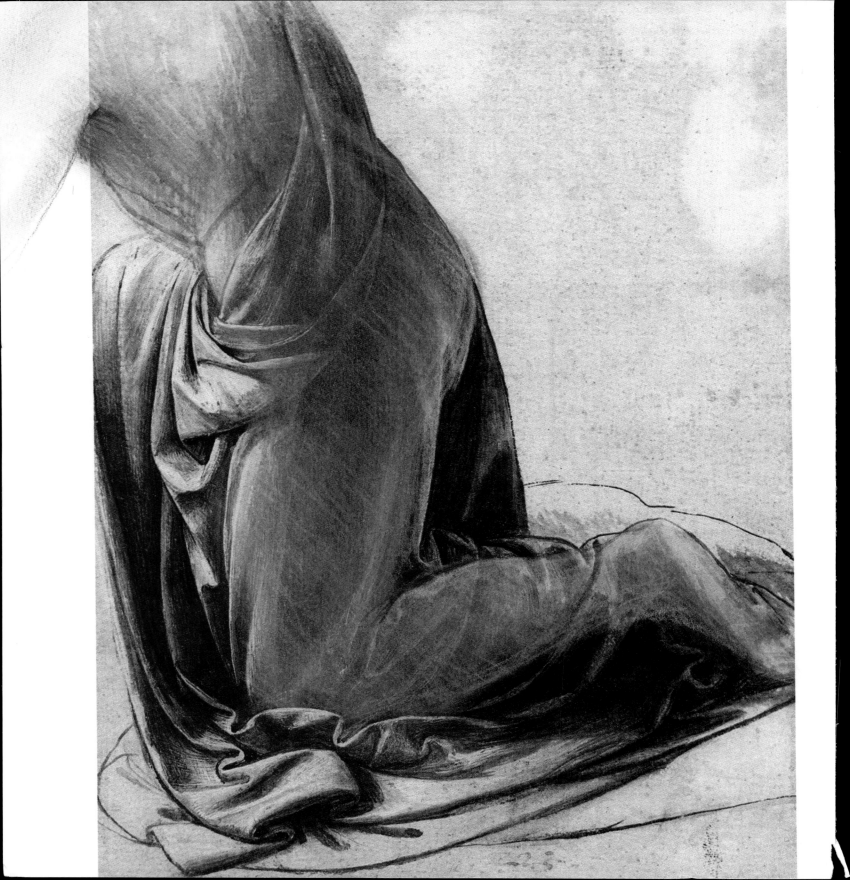

DRAW LIKE DA VINCI

Susan Dorothea White

CASSELL
ILLUSTRATED

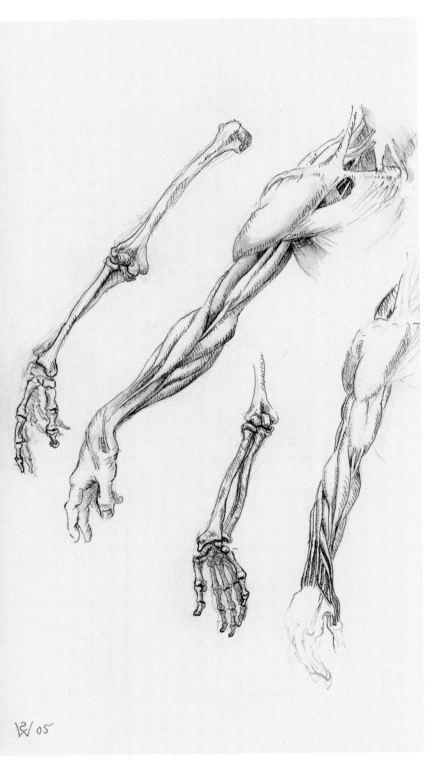

I dedicate this book to family and friends, who keep me looking on the funny side of life, and to every person I have ever taught or drawn.

First published in Great Britain in 2006 by Cassell Illustrated, a division of Octopus Publishing Group Ltd.
2–4 Heron Quays, London E14 4JP

Text and design © 2006 Octopus Publishing Group Ltd
Illustrations © Susan Dorothea White, unless otherwise stated

Text by Susan Dorothea White

The moral right of Susan Dorothea White to be identified as the author of this Work has been asserted in accordance with the Copyright, Designs and Patents Act of 1988

Series development, editorial, design and layout by Essential Works Ltd

All rights reserved. No part of this publication may be reproduced, stored in a retrieval system, or transmitted in any form or by any means, electronic, mechanical, photocopying, recording, or otherwise, without the prior permission of the publisher.

Distributed in the United States of America by Sterling Publishing Co., Inc., 387 Park Avenue South, New York, NY 10016-8810.

A CIP catalogue record for this book is available from the British Library.

ISBN-13: 978-1-844034-44-4
ISBN-10: 1-844034-44-5
10 9 8 7 6 5 4 3 2 1

Printed in China

CONTENTS

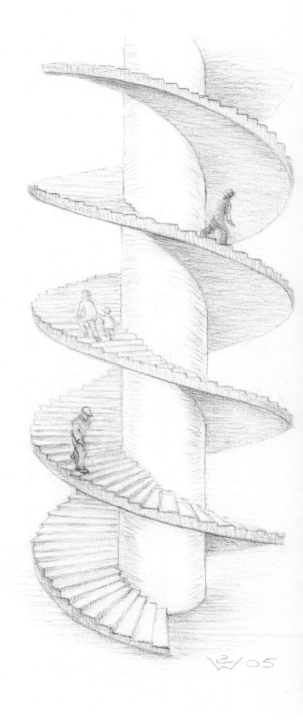

Outline of da Vinci's life

1452 Vinci

Born the illegitimate son of an unknown woman and Ser Piero, a Florentine notary. Obsession with flight commenced in the cradle, when a bird swooped down, touching him on the face. Raised in his father's household; showed a talent for drawing imaginative creatures.

1468 Florence

Apprenticed to studio of Verrocchio.

1470s Florence

Registered in Company of Painters 1472. Earliest surviving drawing (1473); *Ginevra de'Benci* (1474). Anonymous charge (later dismissed) of sodomy brought against Leonardo; *The Annunciation* (c.1473).

1480s Florence–Milan

St Jerome; The Adoration of the Magi (unfinished, commissioned in 1481). Working in Milan at court of Ludovico Sforza for 16 years (1483–99); *Virgin (Madonna) of the Rocks* (Louvre version, 1483–86); *Il Cavallo,* equestrian monument for the father of the Duke of Milan (gigantic clay model, 1493). First period of anatomical studies; extensive notebooks on painting; town planning; architecture.

1490s Milan

The Last Supper (commenced in 1495, completed in 1498). Illustrates Pacioli's *De divine proportione* (1496). Studies on human proportions; designs and paints Sala delle Asse (1498). Left Milan in 1499 following French invasion.

1500s Florence • Milan • Florence

Returned to Florence in 1500 after brief stays in Mantua and Venice. Mathematical and anatomical studies; military engineer for Cesare Borgia 1502–03; worked on swamp reclamation projects and town planning in central Italy. *The Battle of Anghiari* (1503; cartoons and painting subsequently destroyed); *Mona Lisa; Leda and the Swan.* Returned to Milan in 1506. Appointed painter, architect and engineer to Louis XII of France in 1506. Scientific investigations in geology, botany, hydraulics, optics and mechanics. Returns to Florence briefly in 1507. Life-long friendship begins with his student Francesco Melzi.

1510s Milan • Florence • Rome • France

Second major period of anatomical studies, 1509–11. Many pupils. *Virgin, Child and St Anne.* Travel. Settled in Rome 1513 under patronage of brother of Pope Leo X; worked on architectural and engineering projects, and painting commissions. *St John the Baptist* (1514). Moved to France in 1517 at invitation of Francis I. Old master now free to pursue own work in natural philosophy and experimental science, as well as his art. Period of monumental composition drawings of forces of nature (had suffered a stroke before 1517 that paralysed right arm preventing him from painting). Organized court festivals in 1518. Drew allegories and costume designs. Died at Cloux near Amboise in 1519; bequeathed all his papers to Melzi.

Drawn in

The aim of this book is to interpret da Vinci's vision, and to teach visual literacy under his guidance so that the reader gains know-how in artistic expression. The mysteries of da Vinci's art are unravelled through practical step-by-step exercises in drawing, and by demonstrations of the essential skills required to draw like him.

Da Vinci's drawings are deciphered, and the mind's eye trained in visual perception and comprehension. Drawing materials and techniques are described, from metalpoint and prepared grounds to those still in use today, such as chalk and pen and ink. Some traditional techniques are adapted to modern materials. Experimental ones, such as goldpoint on emery paper, are introduced.

By learning to draw the shapes of forms using perspective and proportion, by seeing different planes and angles and by recognising shapes of spaces with as much ease as the shapes of form, you will be able to draw like da Vinci. The book aims to explain da Vinci's approach to perspective and proportion in a novel and entertaining way, to make them easy to comprehend. There are some ideas that may interest the scholar and stimulate debate.

The task of selecting drawings from the output of this protean genius was daunting; choosing what to exclude was agonising. Da Vinci's universal vision can be appreciated by this maximalist list of subjects – horses, dogs, cats, ermines, birds in flight, tiny violets, blackberries, oak trees and acorns, grasses, mountains, rivers, trees, bird's eye-views of landscapes, the moon, avalanches, tempests, town planning, geographical maps, architectural plans, pictographs, polyhedrons, inventions, flying machines, musical instruments, tools, drawing implements, inventions of monumental significance, devices for bronze casting, studies on the flow of water, gears, optics, studies of light and shade, human and animal anatomy, organs, coitus, fetuses, battles, madonnas, drapery, emblems, allegories, ideas for harnessing solar energy...

Da Vinci was left-handed. The book is designed for the dextrous, as well as the sinistrous, making it user-friendly for the right-handed majority as well as for the left-hander. (Some of the drawing techniques of da Vinci are demonstrated in reverse, so that lines are orientated in the appropriate direction for right-handers.)

Quotations from da Vinci's philosophy and his advice to artists and students are included. He recommends that the student study and copy the works of masters – what better mentor to follow than da Vinci himself! I hope to show that drawing is rewarding and enjoyable under the guidance of the greatest draftsman in history.

Poor is the pupil who does not surpass his master.

Inside the mastermind

Leonardo da Vinci was not only a great artist; he was also a scientist, inventor, architect, sculptor, mathematician, theorist, anatomist, writer and teacher – a true Renaissance man in today's terms. He valued art above all as the great communicator. Art is a universal language, recognised in an instant. We may struggle to decode his written words, penned back-to-front with his left hand in old Italian, however we respond immediately to his drawings.

All of da Vinci's creativity is expressed in his drawing and writing – his thoughts, his ideas for paintings, his inventions, his observations of nature and his fantasies.

The secret of da Vinci's mastery of drawing lies in his ability to balance the significance of each line and mark he draws, creating a coherent visual symphony. The art of masterful drawing is the skill in balancing the relationship of all the parts to the whole and the parts to one another, and in assembling them in a hierarchy of significance that satisfies our aesthetic sensibility. However, achieving this harmony is not enough to produce a work of art if passion is lacking.

Where the spirit does not work with the hand there is no art.

Furthermore, there is no way of avoiding a thorough understanding of proportion and perspective, the essential ingredients for masterful drawing, as da Vinci himself stated.

Da Vinci never intended his drawings to be viewed as independent works of art. The approach to drawing during the Renaissance was different from that of today. Drawings were not valued as works of art in their own right, but were merely viewed as a means to an end, as ideas for painting, sculpture, machinery or architecture. Drawings were considered no more a work of art than we would regard a text message or e-mail as literature.

I have been impressed with the urgency of doing. Knowing is not enough; we must apply. Being willing is not enough; we must do.

Da Vinci's sketchbooks are a collection of his thoughts, expressed in drawings and writings on the same page (usually smaller than the standard page today, making the amount of information on his single page all the more remarkable). He jotted down his ideas spontaneously and intuitively, without any pretence. His enquiry was unlimited and included natural phenomena, plants, anatomy, and architecture, and he made copious drawings and notes on his inventions. He dissected bodies, drew them while making anatomical discoveries, and illustrated a book on the divine proportion by his mathematician friend Luca Pacioli with diagrams of complex geometric forms such as polyhedra.

The following statement gives us some insight into da Vinci's insatiable appetite for knowledge, which nourished his genius.

Abbreviations do harm to knowledge and to love, seeing that the love of anything is the offspring of this knowledge, the love being the more fervent in proportion as the knowledge is more certain…. Of what use, then, is he who abridges the details of those matters of which he professes to give thorough information, while he leaves behind the chief part of the things of which the whole is composed? It is true that impatience, the mother of stupidity, praises brevity, as if such persons had not life long enough to serve them to acquire a complete knowledge of one single subject, such as the human body; and then they want to comprehend the mind of God in which the universe is included, weighing it minutely and mincing it into infinite parts, as if they had to dissect it!

Look through da Vinci's art, and you will see that there are hardly any subjects suitable for still-life drawing. There are no vases

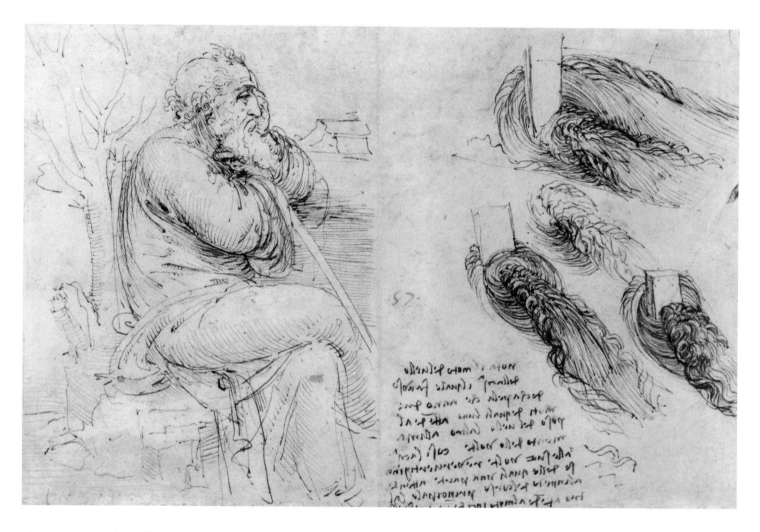

Leonardo da Vinci, The Philosopher (seated old man); Water studies *(c.1513). Pen and ink. 154 x 216 mm. The Royal Collection © 2006 Her Majesty Queen Elizabeth II*

of flowers or pot plants. Plants and grasses emerge from the soil in their natural location. The only static subjects are drawings of his compasses, swords etc. and tiny sketches (drawn sideways) of cups, jugs and saltcellars on a sheet of studies in the *Codex Atlanticus* – perhaps for *The Last Supper*.

Da Vinci's homogeneous sexuality (he was a homo genius like many genii) made him sensitive to the importance of the balance between male and female. This awareness of the harmony of 'yin and yang' is evident in all his work.

Our master was a left-hander – this explains the back-to-front writing in his notebooks. His writing is readable in a mirror. The same applies to da Vinci's shading lines, which are inverted for the eye of the right-hander when viewed in a mirror.

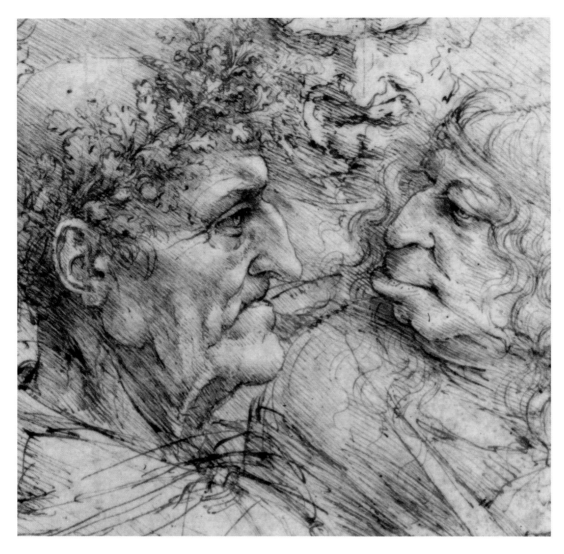

Leonardo da Vinci, Five characters in a comic scene; *detail. See page 125*

The Pensive Scientist *(1978). Drafting pen and brown ink. 37 x 27 cm*

Simplicity is the ultimate sophistication.

The fact that da Vinci abandoned works at many different stages gives us an insight into the workings of his mind, as well as his drawing procedures and techniques. There are traces of his fingerprints on unfinished paintings.

Even though you are learning to draw like da Vinci you will leave your own mark on your work, for drawing is as individual as handwriting.

Art is never finished only abandoned.

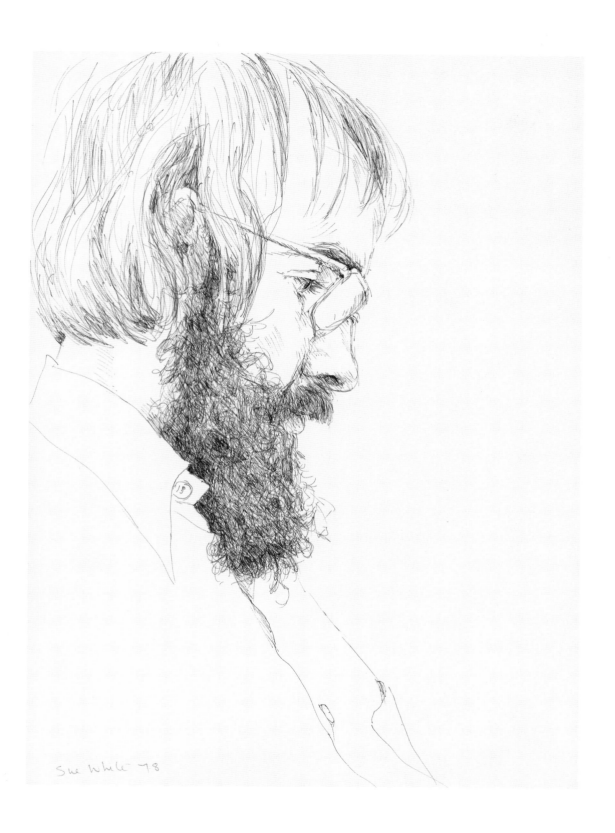

Sue White 78

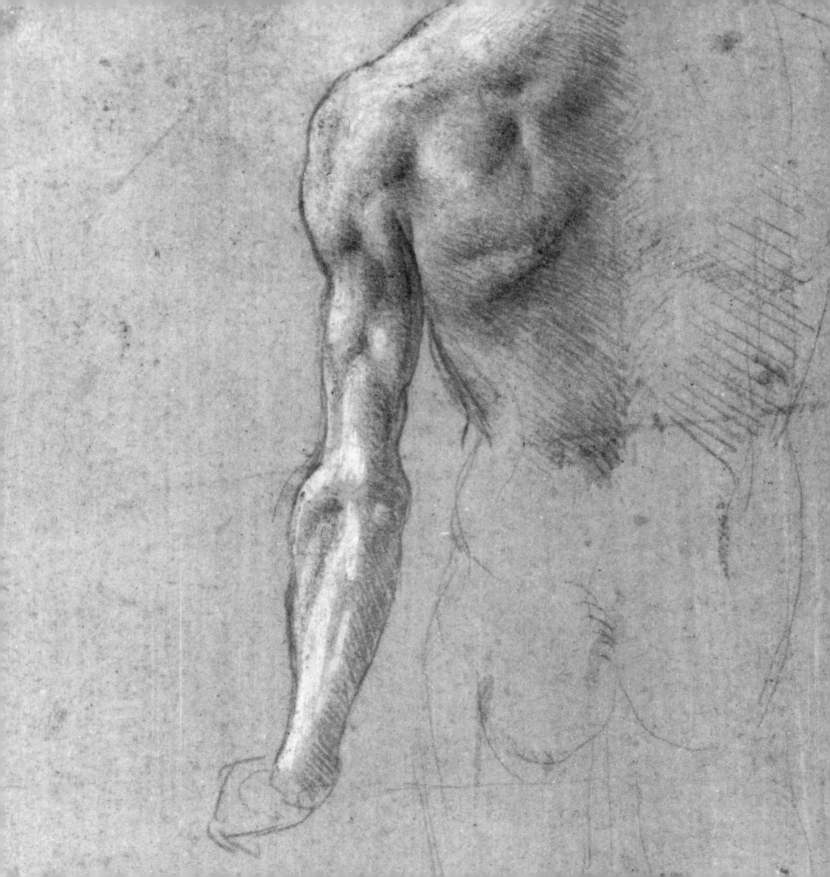

TECHNIQUES AND MATERIALS: THEN AND NOW

This section describes da Vinci's materials, how he used them, and how to adapt them to today's conditions. In the spirit of da Vinci, modern alternatives are discussed, including new experimental techniques and materials.

Da Vinci could be called the first mixed-media artist – in one drawing he might combine five different media. In a typical mixed-media drawing, he used charcoal or black chalk underdrawing, followed by metalpoint, then pen and ink for emphasis, a dampened brush for shading in a light wash, and finally white chalk highlights. Most of these drawings are on specially prepared surfaces tinted with pigment, known as prepared grounds (see section on grounds, page 24). By far the most significant technique for da Vinci was pen and ink on unprepared paper, which he used for his prolific outpourings of drawings, designs, inventions and writings.

Leonardo da Vinci, Male nude from back and side; *detail (see page 109)*

Dry drawers

Dry drawers – chalk, conté, pastel, charcoal, crayon and pencil – are suitable for most surfaces except glossy ones. They respond best to roughened surfaces, such as prepared grounds. There are papers available today with textured surfaces that trap pigment such as pastel, and Ingres papers that are ideal for chalk, pastel and charcoal drawing. Dry drawers are suited for line as well as soft shading effects.

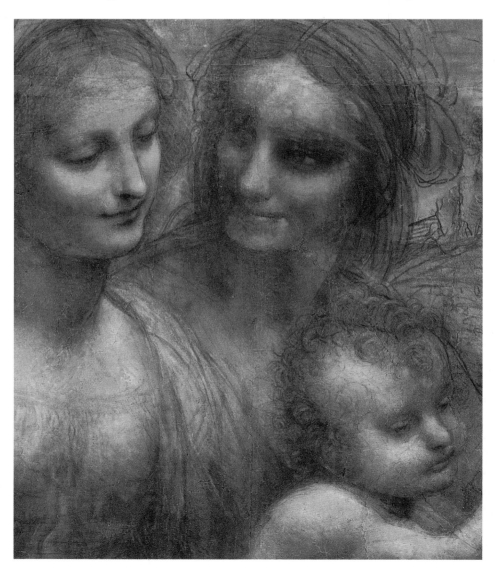

Leonardo da Vinci, Cartoon for the Virgin, Child, St Anne and St John; *detail (see page 62)*

CHALK was a fundamental drawing medium for da Vinci. He used black, red and white. For most of his work he drew lightly with black for the initial underdrawing, including his silverpoint and pen drawings.

Chalk was da Vinci's preferred medium for landscapes and deluges, either alone or combined with pen and ink. In these drawings he sometimes used a damp brush mixed with a little chalk to cast a light shading tone.

For white highlights (or 'heightening'), da Vinci used a dense white chalk. His skill in applying white highlights is evident in the mixed media drawing *Male nude from back and side* (page 109), and in his combination of black and white chalk in *Cartoon for the Virgin, Child, St Anne and St John* (page 62).

For studies of heads and hands, such as for *The Last Supper*, da Vinci preferred red chalk on pinkish toned grounds, made with red earth pigments. This technique of using related tones creates an intimate atmosphere that brings the page to life. This animated effect is one of da Vinci's hallmarks.

Artist-quality chalks are available in stick or pencil form. The hard variety can be sharpened to points for drawing fine lines like da Vinci's. Some artist's chalks are conveniently made to fit the shafts of clutch

pencils. Avoid inferior chalks, such as blackboard chalks, which are made with dyes and clay compounds.

PASTELS are pigments compounded into sticks with a dry binder. A skin of paper is usually wrapped around the shaft of the soft variety to prevent breakage. The hard variety is best for drawing like da Vinci. It comes as a stick, or is encased in wood like a pencil (sometimes called pastel chalk). Artist-quality pastels are made from stable pigments and are therefore permanent. Oil pastels are soft sticks of oil and pigment.

CONTÉ, like pastel, is made from pigments, but also contains wax for added strength. It is suitable for drawing distinct lines and soft shaded passages. A warning: white conté is not as good as chalk for heightening because the wax content reduces its intensity. Conté comes as either a wooden pencil or classic conté stick, which has a square profile. Don't be alarmed when the stick breaks – this creates sharp corners for drawing fine lines. A toned surface can be created by applying the broad side of the conté stick, in light strokes, to white paper and then rubbing with a finger or cotton wool. In addition, a damp brush will give a subtle tone. Drawing with the same coloured conté stick will mimic da Vinci's drawings with red chalk on reddish prepared ground.

Betraying Chalk for Conté (2005). Conté pencil and conté sticks, damp brush wash, paper toned with conté stick and finger. 21 x 16 cm

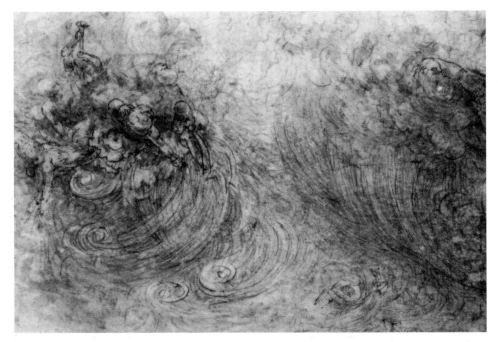

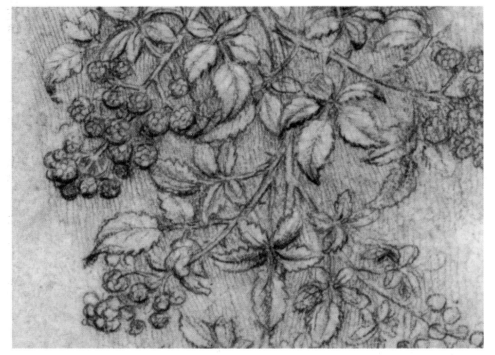

Pen over black chalk underdrawing on paper prepared with grey wash. Detail from da Vinci's Hurricane over Horsemen and Trees *(see page 85)*

Red chalk drawing and white heightening on a prepared ground. Detail from da Vinci's Shoot of Blackberry *(see page 75)*

CRAYONS have a higher wax content than conté, and adhere to a greater variety of surfaces. The wax content makes crayon the ideal drawing medium for lithography. Lithographic crayons are superb for general drawing, but they are made only in black. They are graded from hard to soft. Here is da Vinci's instruction for making coloured crayon to use on *secco* (dry fresco):

To make points for colouring…this wax should be dissolved with water, so that after the white lead has been mixed this water having been distilled may pass away in steam and the wax only remain, and you will make good points.

CHARCOAL is made from slowly heated willow or vine twigs, or from compressed, kiln-fired powder. Willow is the best quality and most suitable for drawing like da Vinci. The coarser vine charcoal tends to scratch.

PENCIL, which is made of graphite, is a versatile standard medium. It is ideal for approaching an unfamiliar subject, and for underdrawing. The first pencils were made from lead. This was replaced when graphite deposits were discovered in England, shortly after da Vinci's time. Because it marks paper without the need for a prepared ground (see page 24), pencil replaced silverpoint as the basic drawing tool. The common pencil could be called the silverpoint of today.

Keep your points as sharp as your wits, as da Vinci did. Always have that pencil sharpener handy (or a knife if you prefer). If ends break off in the pencil sharpener, use a toothpick to remove them; a metal implement will blunt the blade.

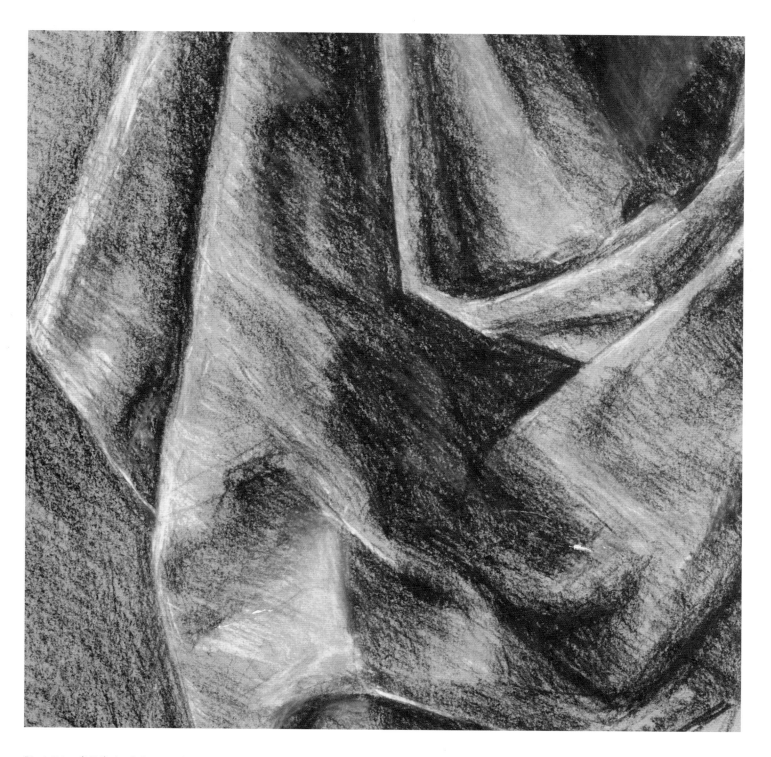

Black Velvet *(1961); detail. See page 86*

Skill with ink and quill

The quill pen and ink technique was da Vinci's talisman. He used the quill for his notes, writings and the vast majority of his drawings. The quill is a calligraphy pen made from a goose feather, and makes a broad downstroke and a fine up- or sidestroke.

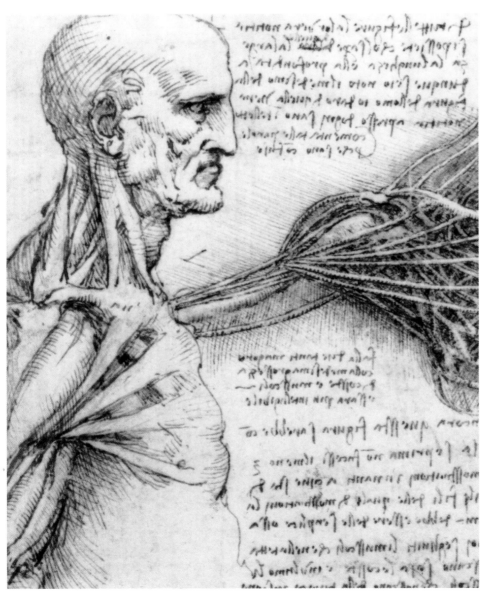

Think pen and ink

The ink that da Vinci used is called 'iron gall'. A black, water-soluble ink, it was used by ancient scribes, Bach and Rembrandt, as well as by our master. Iron gall ink fades from black to brown, so to visualise da Vinci's drawings in their original state we need to interpret brown as black. It is also unstable and contains iron sulphate which attacks paper, so that many of da Vinci's drawings are damaged by corrosion.

Da Vinci used unprepared paper for most of his ink drawing and writing, though he used pen on parchment to illustrate Pacioli's *De divina proportione*. Sometimes he used ink on prepared grounds to enhance his silverpoint and mixed media drawings. For detailed studies, he drew rough feint lines in black chalk before committing pen to paper. Da Vinci's secret for creating a rich effect and depth was to weave many tones and textures, and to vary the intensity of the ink.

In da Vinci's time paper was a rare commodity – this explains why da Vinci used every square inch of his manuscript pages, drawing and writing on many different subjects on the one page, filling it in, sometimes sketching sideways and even

Leonardo da Vinci, Studies of the anatomy of the shoulder; *detail (see page 103)*

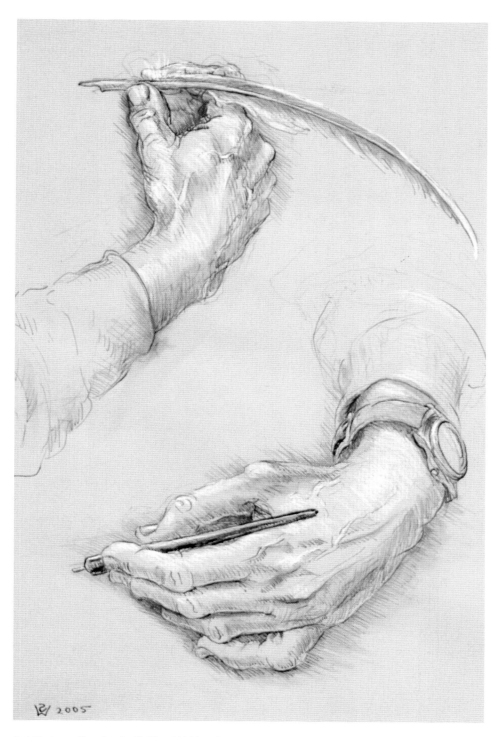

Ambidextrous: Drawing the Quill and Making the
Point *(2005). Pen and white highlights. 30.5 x 21 cm*

upside down. He often used the back of the
page; the front and the back of the page are
termed 'recto' and 'verso' respectively.

As light as a feather

The longest flight feathers of the goose wing
make the best quill pens. The shaft of the
feather is tempered in warm sand before
the nib is carved. The fine lines in da Vinci's
drawings show us that he was an expert in
shaping and sharpening the quill (it loses its
edge quickly). Da Vinci would have kept a
penknife at hand for frequent resharpening.

Take the plunge

Choose a pen that suits your style. You can
purchase a ready-made quill pen, but if you
find the quill hard to handle, or lack the skill
to re-carve the nib over and over, then use
the old-fashioned metal nib and holder; it
will produce the same effect as a quill and
is more convenient. A fountain pen with a
calligraphy nib is another alternative.

Most modern pens make lines of
consistent thickness. These include the
drafting pen with a set of round steel (or
tungsten-tipped) nibs of different diameter,
and the novel Venetian glass pen. Permanent
artist-quality felt-tipped pens come with a
variety of tips – point, chisel or brush.

To mimic da Vinci's fine-line drawings
from his middle period (e.g. *Five characters
in a comic scene;* page 125), use pens such
as the Venetian glass pen, a fine drafting pen
or a fine pointed felt-tipped pen. Or simply
use a calligraphy pen with the nib side-on
to the paper. Today's inks are stable and
permanent, waterproof or water-soluble,
and there are non-clogging varieties.
A suitable alternative for iron gall ink is
water-based shellac ink.

Brush

Da Vinci used brush for tone washes in some of his drawings to enhance details. He kept the wash lighter than the shading lines. In chalk drawings he used a damp brush to pick up chalk pigment for subtle tones. For drapery, however, he applied the densest black with brush in the shadows of folds. Some of his initial composition ideas are sketched in brush and ink. In one example, a Virgin emerges from a blob of ink, vigorously brushed then penned.

According to the Early Renaissance painter and writer Cennino Cennini, the best brushes (and presumably those used by da Vinci) were made from the winter white fur of the minever, a type of weasel. Long sable-haired, oriental-style brushes are an excellent equivalent.

Always use a brush with long hair, with fibres that come to a point. To test the brush, dip it in water and give it a flick to see that all hairs merge at the tip. A convenient brush for applying damp washes is a synthetic brush with a reservoir of water in the handle.

Using a brush for drawing requires skill in controlling the right amount of moisture and pigment – too much water and the paper buckles, too much pigment and the line drawing is obliterated. If you find yourself stranded without brush or water, use your finger dampened with saliva. After all, fingers were made before brushes!

Leonardo da Vinci, A scythed chariot, 'armoured car' and pike; detail (see page 72)

This detail illustrates da Vinci's skill in using watercolour wash to show form

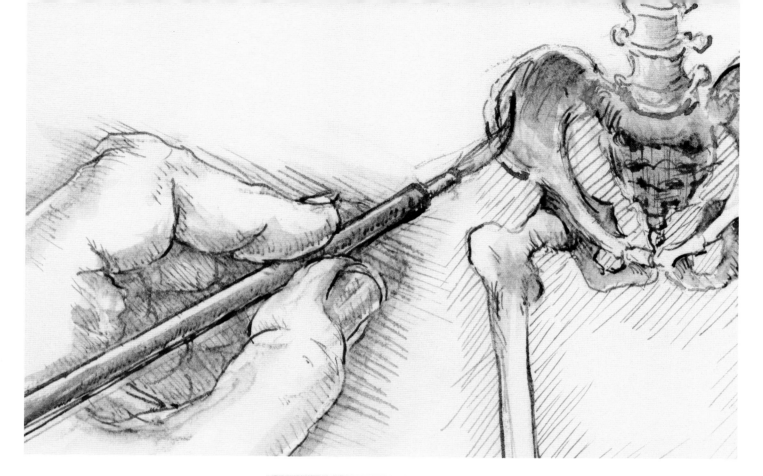

Applying Brush Tones For Form; *detail (see page 107). The bamboo handle is typical of the long-haired, oriental-style brush*

Brush and Pastel for Drapery, *2005; detail (see page 89)*

Metalpoint – silverpoint

The term 'metalpoint' refers to both the actual drawing itself and to the implement used to create it. The implement is a piece of metal wire, called a stylus or style, which is inserted into a handle. Metalpoint requires a specially prepared fine abrasive surface, known as a prepared ground, to make a mark. It will not leave an impression on ordinary paper or on groundless surfaces.

Making the point about silverpoint

Silverpoint is often called metalpoint, which is confusing. Although silver is the most suitable metal for drawing, many soft metals can be used, including gold, brass, copper and lead.

Da Vinci's metalpoint drawings are silverpoints. Silverpoint has a unique quality compared to other metalpoint. The mid-grey silver colour changes over time to a deep brown. This is due to the oxidisation of the silver, and is known as 'patination'.

Using paper prepared with coloured grounds, da Vinci produced many exquisite silverpoint drawings. Silverpoint suited his expressive style and shimmering shading. He often combined silverpoint with white chalk highlights and pen and ink.

Patination (oxidisation) of the silver from grey to brown. Detail from da Vinci's Studies of a woman's hands, *drawn on a prepared ground (see page 114)*

Metalpoint is a permanent technique that cannot be erased and does not smudge. It requires deft skill, control and patience, as it is a gradual process of building up the tone by going over and over the same lines. The stylus is applied in gentle strokes, lightly touching the surface – digging into the ground does not increase the tone. Initially the tones are mid-grey (until the silver darkens to a deep brown on ageing).

The art of metalpoint drawing peaked in popularity during the Renaissance, when it was the basic technique for artists and students alike. The student practised on the same board, scraping away each completed drawing before re-coating the board with fresh ground for the next. Fortunately, many of da Vinci's silverpoint drawings are on prepared paper and so have survived. *The Warrior* (*c.*1472) is one of his earliest drawings. The depth and subtle beauty of metalpoint has prompted a recent revival.

To make your point
Purchase soft (annealed) silver wire to match the diameter of the shaft of a propelling or clutch pencil, or insert the wire in a wooden holder or even a pin vice. The wire can be cut on a diagonal with side-cutters to create a chisel end for broad, soft strokes. The other end can be sharpened to a point on a grinding stone or sandpaper for drawing fine lines.

Silverpoint Techniques: Drawing Lock of Hair Using Wire in Clutch Pencil Holder; Enlarged View of Pointed and Chisel Ends of Wire; *detail (see page 24)*

Additional instructions on drawing with metalpoint are on page 24

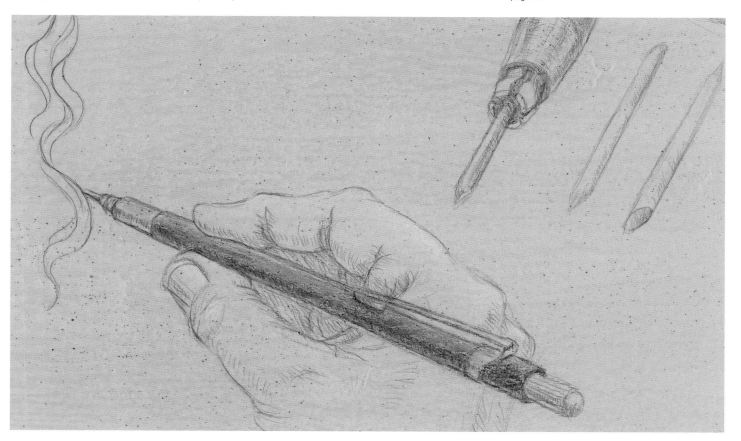

Grounds for mixed media

A ground is a specially prepared surface made from finely milled white pigments that act as an abrasive (such as zinc oxide). The abrasive, known as the 'tooth' of the ground, captures the tiny particles of metal as the stylus passes over the surface. The finer the grain, the more responsive the ground and the darker the impression. If too coarse, the stylus will not even leave a mark. Prepared grounds have a depth and sensuous texture rather like fine chamois.

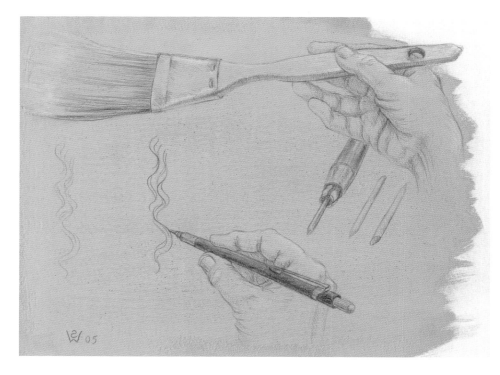

Silverpoint Techniques: Drawing Lock of Hair Using Wire in Clutch Pencil Holder, Applying Ground with Flogger, and Enlarged Wires and Clutch Holder (2005). Silverpoint, coloured pencil, conté on blue prepared ground. 20 x 28 cm

Apply the ground lightly and quickly with a flogger brush, holding the handle as shown. Notice that the hand holding the brush (drawn in silverpoint) does not extend beyond the edge of the ground – the stylus cannot mark the unprepared surface of the paper.

A simple ground with Chinese white

You can make a ground that will respond to metal by simply painting a surface with Chinese white (an old trade name for opaque white watercolour paint made from zinc oxide and gum arabic). Chinese white, with a small amount of coloured pigment, provides a convenient alternative to the traditional Renaissance recipe made with rabbit skin glue, although the gum is an inferior binder to the glue. Several thin coats are better than one thick one.

Renaissance recipe

The recipe used 500 years ago is still valid today. With some modifications, the ingredients make a surface that will last for the next 500 years, as have da Vinci's silverpoint drawings. You can skip Ceninni's advice to collect chicken thighbones from under the table to burn to a fine white ash! The ash was mixed with saliva (the binder), water and lead white to make a metalpoint ground that was applied to a board.

Today lead white is replaced by zinc oxide, for obvious reasons. Human spit was considered sufficiently adhesive for a student's temporary drawing before it was scraped off for the next. For permanent drawings, paper was prepared using quality animal skin glue.

The preparation of a ground is worth the challenge if you are not put off by the thought of lumps of hard-to-remove ground splattered about. (There are discrepancies in the textbooks and kits, concerning the amount of glue. Too much spoils the tooth, preventing chalks and conté from adhering.)

What you will need:

- A packet of dry rabbit skin glue (this is a strong adhesive, difficult to remove once dry)
- white pigment (zinc oxide)
- fine-mesh fabric
- thermometer
- clean water
- dry pigment for colour if required
- mask for pigment powder and glue-smell
- double saucepan (or porringer, basin etc. on a steamer)
- metal whisk
- large spoon
- thick paper (cotton watercolour paper is best) or quality cardboard or plywood panel
- longhaired, broad flat brush (called a flogger) for applying the ground
- plastic and/or newspaper sheets to protect working area from splatter.

1 Sprinkle 1 part of dried rabbit skin glue granules over 40 parts of room temperature water (the less water, the harder the ground). Whisk the mixture thoroughly and allow it to stand for an hour.

2 Heat the glue mixture in a double saucepan, or in a basin over a steamer, to about 50°C. Do not heat over 60°C. Gradually stir in sufficient fine zinc oxide powder to obtain a smooth creamy mixture (up to about 70% by weight of zinc oxide for the volume of glue mixture you started with – e.g. for 400 ml of water, you will need about 280 gm of zinc oxide).

Rabbit Watching Process of Heating Rabbit Skin Glue in Double Saucepan Before Adding Zinc Oxide, Testing Temperature with Thermometer, *Rabbit Watching (2005). Graphite pencil and coloured pencil. 19 x 19 cm*

3 Add pigment at this stage if you are making a coloured ground.

4 If necessary, the liquid ground mixture may be filtered through a fine sheer fabric before application.

5 Using the flogger, brush on an even layer of the ground in one direction. Allow the ground to dry thoroughly before sanding lightly and applying a second coat at right angles. Apply three to four coats, sanding between each one.

6 Store liquid ground in a refrigerator between use. Re-heat to a maximum of 55°C to melt the ground before application.

7 Wash all tools and brushes thoroughly immediately after use, as the ground sets like a rock.

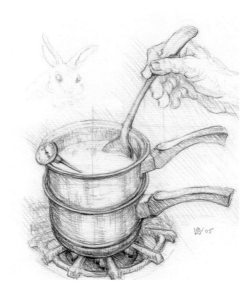

Colouring the ground

Renaissance artists made their own colours by grinding stone or pigment. Typical pigments were earth red, *terre verte* (earth green) and various blues extracted from lapis lazuli in a laborious process to separate ultramarine. Da Vinci drew on buff, red ochre, pale pink, blue and green grounds. He favoured a ground of pale grey-green-blue (robin's egg blue) for his silverpoint drawings of figures and proportional studies of faces and horses. If you want to colour the ground, use dry artist-quality pigments.

The word 'gesso' (Italian for chalk) is used loosely today to mean any ground for artwork. It also refers to a gypsum or alabaster mixture applied to a wooden panel, used in the Renaissance period as a painting surface. The cartoon drawing was transferred to the gesso surface.

Buying ready-mades

A ready-made gesso panel from an art supplier is a suitable surface for metalpoint drawing. These boards save the hassle of having to make a ground yourself. The disadvantage is that you cannot mix a colour pigment with the ground to achieve the soft effect of da Vinci's tinted grounds. However, you can tone down the stark white of the board by applying watercolour, gouache or acrylic washes. Apply several layers, in alternating directions at right angles (see *Allow the Tea to Draw*, page 61).

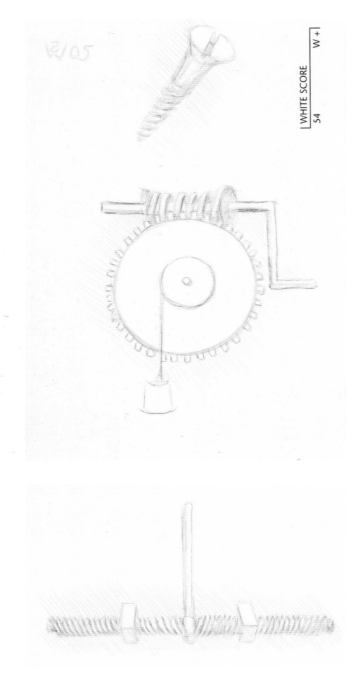

Modern alchemy

ACRYLIC PAINT. Quality matt acrylic paint is another excellent ground for metalpoint, and is easy to apply to paper or cardboard. The free acrylic sample colour cards in hardware stores will actually respond to metal – brass keys and screws leave a defined mark – however, the surface is not as good as a prepared ground. Even some coated commercial printing papers will take metalpoint. Before throwing out that junk mail, try drawing on the back of the brochure!

TOOTHPASTE. This can also be used to make a ground for metalpoint (see page 22) – it has sufficient tooth to bite the stylus! Try mixing three teaspoons of toothpaste with half a teaspoon of PVC glue and a quarter of a teaspoon of watercolour paint. You may need to add a few drops of water. Apply the goo with a wide brush.

GOLDPOINT. For the cost of a few coffees, you can buy a small length of 18 carat gold wire that will last you a lifetime for goldpoint drawing. Insert the wire in a holder as described for silverpoint.

EMERY PAPER. Emery paper is paper or cloth coated with silicon carbide used for polishing metal. Fine grade emery paper (1000 grit and above) in a dark colour suits goldpoint. Interesting effects are obtained by combining goldpoint with chalk, conté or pastel. Note that dark emery is not suited to silverpoint; you might see the line initially but it will disappear as it darkens over time.

Modern scribing

A common misconception is that the grey graphite pencil is a similar colour and texture to silverpoint. Lines drawn from sharpened pencils are similar in appearance to freshly drawn silverpoint. However, silverpoint lines do not smudge, cannot be erased, and will eventually darken.

The ballpoint pen has a uniform line rather like metalpoint, and the characteristic subtle shading of metalpoint can be achieved to some extent.

Da Vinci's Inverted Screw and Worm Gear, Modern Screw (2005). Drawn with a brass screw on acrylic paint sample cards. 11 x 7 cm; 4 x 7 cm

Contemporary drawing surfaces

Many different drawing materials and papers are available today. Scrap paper, old envelopes and brown paper are all suitable for sketching and doodling.

For serious studies there are quality papers such as 100% cotton, handmade mulberry or coloured pastel paper. You can even make your own by recycling quality scrap paper. Cardboard, as used by the Impressionists, is an excellent surface for pencil, pastel, conté and graphite sticks. Fine sandpaper has a satisfying surface for drawing in pastel and chalks. Coloured pastel paper responds to most drawing materials, and saves you from having to coat your paper with a specially prepared ground. The advantage of a toned surface is that it can be heightened with lighter shades.

Stark white paper can be confrontational – spilling a cup of coffee on it will improve its potential as a drawing surface! You may prefer to apply a wash of dilute ink or watercolour, or rub pastel or chalk pigment onto the paper with finger or cotton wool.

Gilding the Lily; *detail (see page 94)*

This is an example of mixed media using goldpoint, white chalk and charcoal on emery paper. The process is described in the exercises on pages 95–97.

Violets *(2005). Biro on paint colour sample card.*
11 x 7 cm

DA VINCI'S SKILLS REVEALED

Da Vinci developed such a phenomenal skill that he could draw from memory and imagination alone. Perspective, proportion and light and shade became second nature to him, so that he was able to express himself without the restrictions that hinder us when we struggle to draw our ideas.

What makes da Vinci's style distinct from any other is that he drew and painted the atmosphere, the spaces and movement of air, as well as the pulse of the subject itself. This is what we respond to when we marvel at his work and wonder why it is so alive. There is always movement in da Vinci's art – movement of the head and arms in his portraits, movement in studies of water and clouds, and potential movement in his engineering drawings and in the curves of his architectural designs.

Leonardo da Vinci, A Cloudburst of material possessions *(c.1510). Pen and ink with traces of black chalk. 117 x 111 mm. The Royal Collection © 2006 Her Majesty Queen Elizabeth II*

In this drawing, da Vinci combines imagination with his experience of floods and deluges in the Arno valley, when people's possessions were washed away.

Da Vinci's approach, advice and devices

The youth should first learn perspective then the proportion of objects. Then he may copy from some good master to accustom himself to fine forms. Then from nature, to confirm by practice the rules he has learnt. Then see for a time the works of various masters. Then get the habit of putting his art into practice and work.

To draw like da Vinci, you need to follow his advice. Train your visual mind to understand the shapes of forms and spaces, to recognise angles and directions of lines, to appreciate proportion, to understand perspective, to recognise gradations in tone and, above all, to be inspired by imagination. Without these, all the technical skills in the world will not produce a work of art.

Draw on imagination

The faculty of imagination is both the rudder and the bridle of the senses.

Da Vinci always drew from imagination. As a child his aptitude for art first came to notice when he designed a shield of imaginary monsters. In his allegorical drawing *Pleasure and Pain*, one figure branches into two at the torso where a male and female emerge, representing pleasure and pain. Da Vinci was inspired by opposing forces in nature, as seen in his drawings of clouds and water, and *King Neptune*.

To follow da Vinci's philosophy, allow curiosity to inspire you by adopting a policy of investigation as well as observation, irrespective of what you draw – people,

buildings, animals, plants, landscape or even plumbing. Da Vinci's secret for creating a convincing smile is to understand what lies beneath the skin. If you want a challenge, study staircases and try drawing a spiral one! Keep a sketchbook with you to jot down ideas and draw what happens around you.

Draw anything and everything using whatever paper is at hand. Sketch a face on a menu or programme with a ballpoint pen, or outline a construction site on an envelope with a marker pen. Da Vinci drew on small pages, filling them with sketches. He made a series of pages showing people at work. On one of these sheets (measuring 291 x 138 mm), he drew no less than 28 figures.

Be carefree, not careful, by drawing with a free hand – exactitude is not art. Creativity comes from chaos, and from a mind that is

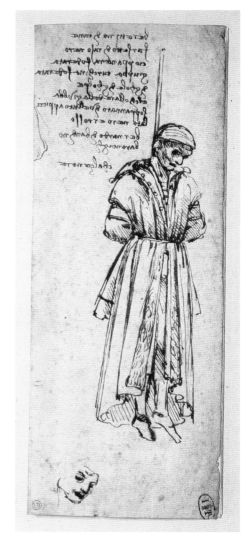

Leonardo da Vinci, Hanging body of Bernardo di Bandino Baroncelli *(1479). Pen and ink on paper. 192 x 73 mm. The Art Archive / Musée Bonnat Bayonne, France / Joseph Martin*

Bernardo di Bandino Baroncelli was hanged for the murder of Giuliano de Medici. His body was exhibited from the window of the Palazzo del Capitano di Giustizia in Florence, when da Vinci would have made this sketch. His text at top left is a note of the colours and the materials of the hanged man's clothing.

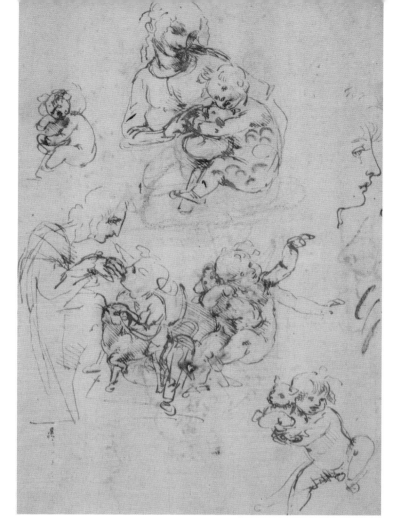

Leonardo da Vinci, Studies for a Madonna with a cat *(c.1478–80). Pen and ink with suggestion of black chalk underdrawing. 274 x 190 mm.*
© *The Trustees of the British Museum*

On a single page da Vinci rapidly sketches many views of a mother and child playing with a cat. His masterful skill captures the natural fleeting movements of a mother and child, one of his favourite subjects. His pen skips over the page, keeping pace with the baby and cat.

Columbia University Medical Center Cafeteria, New York (1998). Drafting pen and ink. 19 x 24 cm

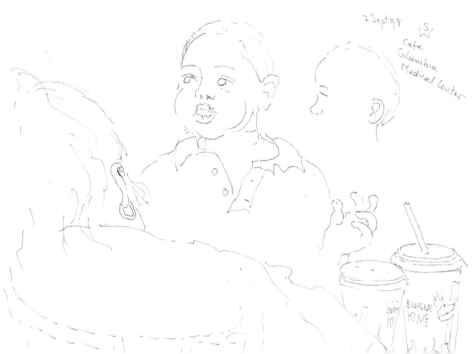

not restricted by tidy boundaries and compartmentalised ideas, so there is no need to be precious about your work.

Throw away your erasers. Rubbing out is not Renaissance – da Vinci did not rub out. Erasing will remove valid parts of the drawing. Retain your changes of mind, guidelines and feeling lines. In da Vinci's silverpoint drawing *Studies of a woman's hands* (see page 114), notice the abandoned thumb in the middle of the page where he changes his mind and decides to place the hand higher up. This does not detract in any way from the beauty of the drawing, but adds life to the work, leaving an indelible thought behind on paper.

The minute you start rubbing out, you reduce your lively drawing to a deadly diagram. Forget about thinking in terms of accuracy and mistakes. The ignorant viewer who judges work in this way sees only a maze of mistakes instead of a work of art. The inkblots, smudges and even fingerprints on da Vinci's pages add to the dynamics of his art. The drawings claimed to be by da Vinci that are suspiciously perfect are probably fakes.

Doodling stimulates the brain and lubricates the hand. Doodling is the ideal

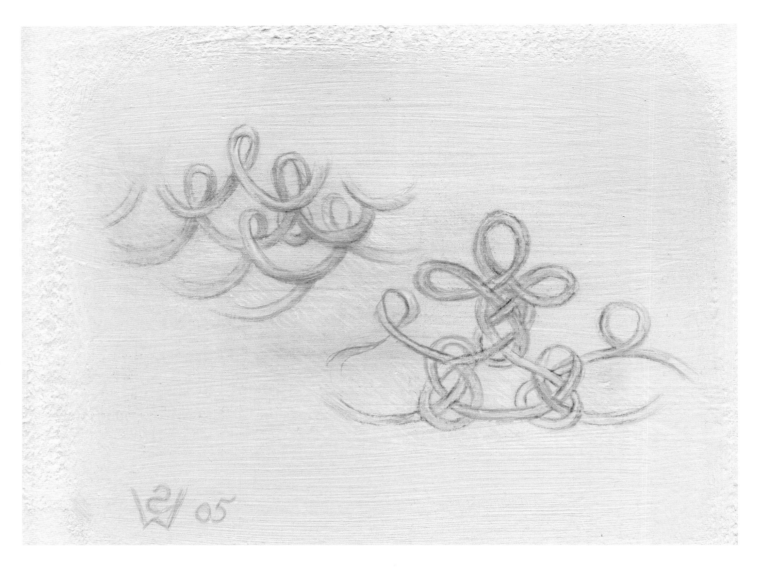

way to test a drawing tool, in the same way that a musician tunes up. Da Vinci's pages are dotted with quick sketches that he would have regarded as doodles, though to us they are sophisticated drawings of locks of hair, eyes, leaves and profiles. Start with squiggles and simple spirals, before advancing to double helices and Celtic knots.

Develop the habit of combining sketches and text as da Vinci did. A typical page of his drawings might have the explanations for the actual drawings interspersed with notes for future projects, profound thoughts unrelated to the drawings and a shopping list written in haste. He sometimes sketched over his writing or sideways in the margins to conserve paper. Illustrate your notes; sketch a knob of garlic and a fish when jotting down a recipe. Da Vinci made maximum use of valuable paper, returning to his sheets time and again to use gaps or even to sketch over the top of previous work.

Perceiving patterns

Patterns are not only satisfying to the eye, they are the pulse and texture of an artwork. In da Vinci's painting of trees in the Sala delle Asse in Milan, a single, unbroken golden ribbon winds its way through the patterns of leaves and branches in an intricate looped motif. We see similar knots in the ribbon on the garment in the painting of *Lady with an Ermine* (Krakow Museum), as well as in da Vinci's doodles.

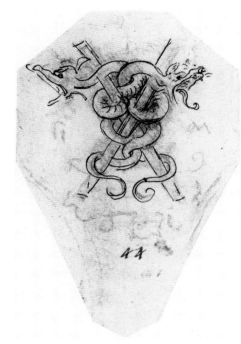

Gold Ribbon from da Vinci's Sala delle Asse Design
(2005). Goldpoint and pastel on ground prepared with
terre verte and toothpaste. 16 x 19 cm

Sforza Restored from da Vinci's Sforza Emblem
with Snakes (2005). *Black chalk underdrawing,
pen and ink, giclée. 100 x 66 mm.*

Leonardo da Vinci, Study for the head of Leda;
detail (see page 79)

*In Leda's hair, da Vinci combines his favourite
patterns – helices, plaits, interweaving and
inversion. Deterioration caused by corrosion of
iron gall ink is evident in this detail.*

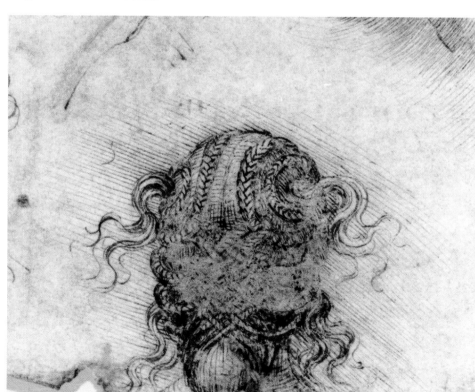

The spiral form was fundamental to
da Vinci. He drew patterns that he observed
in nature, such as vortices in water, growth
spirals in plants and hair tresses. Inverted
shapes and patterns permeate his work,
as in the pictures here. He used the planar
symmetry of the human body as a device
for inverted patterns, such as the gestures
of hands in his *Last Supper* painting.

Encompassing devices

When he needed precision for subjects such
as light and shade, studies of the moon and
architectural plans and perspective, da Vinci
used instruments such as compasses and
rulers. His reliance on drafting tools and
rulers is evident in his study of rays of light
reflected from a parabolic concave mirror.
His notes show that he realized the potential
for using mirrors to harness solar energy.
Vitruvian Man is framed within both a circle
drawn with a compass and a square drawn
with a ruler. Da Vinci ruled perspective lines
in some of his compositional drawings,
notably for *The Adoration of the Magi*.

Da Vinci sketched a device for drawing
parabolas and one for drawing ellipses
(since lost) that Dürer used. Our master
was fascinated with optical devices such as
the perspectograph (a drawing aid) and the
camera obscura. He wrote instructions on
how to use the perspectograph, making a
tiny sketch of a man using one in the *Codex
Atlanticus*. From his drawings and writings
on the optics of the eye, it is clear that da
Vinci made the connection between visual
optics and the camera obscura. However, he
had no need himself for such cumbersome
novelties. These devices could not replace
visual skills, any more than opto-electronic
technology can today.

To see or not to see

The painter who draws merely by practice and by eye, without any reason, is like a mirror, which copies everything in front of it without knowing about them.

Human nature and the natural world have not changed since da Vinci's time, but our environment has become polluted with distorted imagery on the flat screen, print media and candid photographs. These invasive images do not teach us to see – they indoctrinate us with visual stereotypes. It is not surprising that many believe they can produce an artwork by merely copying photographs or the subject in front of them, 'parrot-fashion', blissfully ignorant of the fact that, to interpret and translate the visual world into a convincing artwork, a trained eye is essential.

Once you have mastered the art of drawing, you will have the skill to extract information from photographs and digital images (as in the example on page 129). The art of photography is quite different from drawing, with its own demanding technical and visual expertise. No doubt if da Vinci were alive today, he would have incorporated modern technology in his work. However, in the hands of people lacking visual literacy, such technology produces an ugly pastiche.

It is only through drawing, painting and sculpting that we learn to observe and understand what we see. Clearly da Vinci's drawings are in no way representational or photographic; his driving force was his passion and imagination. Cast shadows, which are so dominant in photographs, are de-emphasized by da Vinci in favour of the softer shadows that mould the form. Furthermore, photographs are not suited to conveying movement. For example, a snapshot of a bird in mid-flight conveys no sense of motion like da Vinci's birds, where he even indicates the air currents. A photo of a racehorse is like a wooden rocking horse, whereas da Vinci's horses are rearing and galloping with their limbs in several positions.

Seeing the positive side of negative space

Train your eye to see the shapes of spaces. Recognising the positive side of negative space assists you to draw the contour of a form and visualise proportions. Spaces are as vital to your drawing as the actual forms. In da Vinci's drawing, notice how the shape of the horse's head and the shape of the space mimic each other, forming a yin-yang symbol.

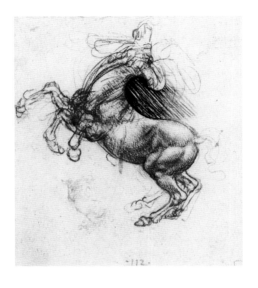

Yin and Yang in Horse: Positive Side of Negative Space *(2005). Black chalk and giclée. 14 x 12 cm. From da Vinci, 'A Rearing Horse', c.1505*

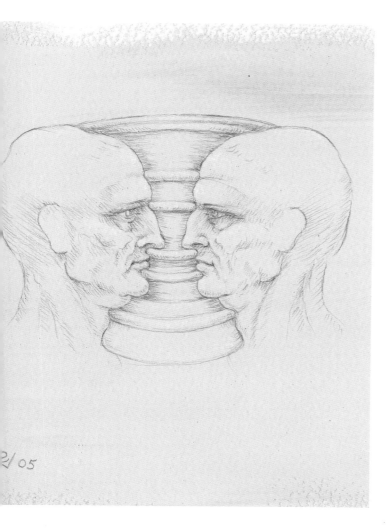

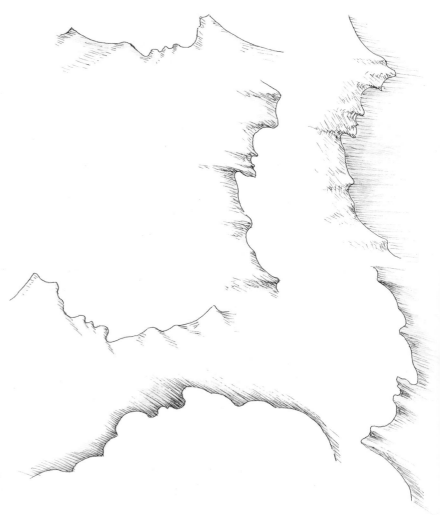

Now you see it – now you don't

The human eye has difficulty seeing the shape of a space when it lacks a boundary as a reference. When enclosed, the shape is easily recognised. The shape of the space around a face in profile may be difficult to grasp; however when a space is boxed in, its shape becomes obvious. The familiar example is the shape defined by two identical profiles facing each other. The mind's eye alternates between seeing the outlines of two faces and the vase between them.

When a boundary is repeated in a band, such as the frame of a window or the inner and outer contour of a toilet seat, the enclosed space becomes especially easy to recognise. The repetition of the outline reinforces the shape in our mind. The window is a favourite device of da Vinci's for framing portraits.

Shared Silver Cup Award (2005). Silverpoint, white heightening on blue prepared ground. 19 x 25 cm

Profiles – Cliffs, Spilt Milk, Mountains (2005). Pen with wash. 29 x 21 cm

A challenging drawing exercise is to create rugged skylines, cliffs and so on by using profiles re-arranged, upside down or sideways, and then drawing shapes either side of the contour. Turn the book around to see the profiles.

Deciphering da Vinci's line language

Line was da Vinci's main means of expression in drawing. He used line for contours, shaping, shading, backgrounds, highlighting and movement. He even animated spaces and atmosphere with lines.

Leonardo da Vinci, River running through a rocky ravine with birds in the foreground; detail (see page 81)

Da Vinci makes the gorge disappear in the distance behind straight horizontal hatching lines.

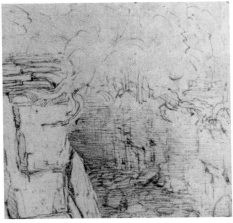

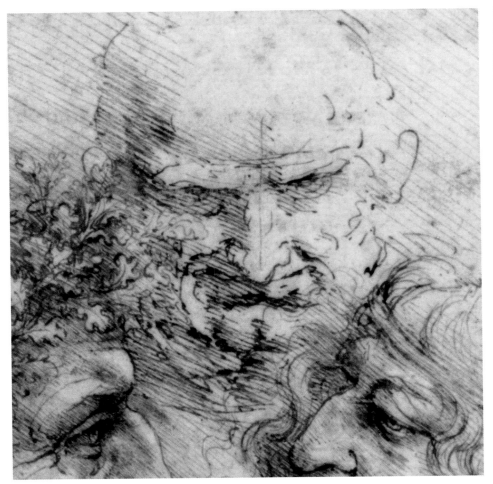

Leonardo da Vinci, Five characters in a comic scene; detail (see page 125)

Observe da Vinci's characteristic use of straight parallel hatching lines, that continue from the background across the contour of the form to create depth. Here they make the head recede in the distance.

For shading and highlighting, da Vinci used various hatching techniques – single hatching with straight and curved parallel lines, crosshatching and multi-hatching (in all directions). Hatching leaves gaps between the lines, allowing the page to show through even in the densest shadows where there is still shape. Similarly, for heightening with white chalk, da Vinci employed lines with subtle variation in intensity, utilising space between the lines to create tonal variation and to mould shapes.

The rare occasion when da Vinci used solid shading is in the shadows in drapery folds. Lines are still seen in places. The cartoon for the *Virgin, Child, St Anne and St John* is an exception, where the drawing verges on tonal painting with the smooth

blending of black and white chalk. Line is used here only to define contours.

Not to be forgotten are the under-drawing lines in black chalk where da Vinci roughs out the shapes first. These soft grey lines add texture and would have blended with the tone of the black ink. Now that the ink has faded to brown, these under-drawing lines are more obvious than they would have been.

Da Vinci's straight parallel hatching

This unique technique was invented by da Vinci for shaping with shading, for backgrounds and for superimposing a veil of atmosphere over a form. The skill of controlling the lines so that they all run in the same direction and are equidistant from each other requires practice.

A significant aspect of da Vinci's use of these hatching lines is the softening effect obtained by continuing the lines from the background across the contour onto part of the subject to distance that part. This creates depth by placing an atmosphere between the viewer and the form. It is a sfumato technique in drawing like da Vinci's use of sfumato in painting, but is seldom recognised as such. His *Five characters in a comic scene* (opposite) shows how he used this deft skill. Artists since da Vinci have adopted this technique of straight parallel hatching over the parts of the drawing that should recede to the background.

Demonstration of Hatching for Right- and Left-handers (2005). Drafting pen and ink. 14 x 28 cm. Based on da Vinci's 'Test for the wing of an "Ornitotero"'

The natural inclination is to shade on an angle (obliquely). Left-handers and right-handers shade in opposite directions. The left-hander's downward stroke is from top left to bottom right, and their upward stroke is from bottom right to top left. The right-hander shades the other way round – the downward stroke is from top right to bottom left, and upward is from bottom left to top right

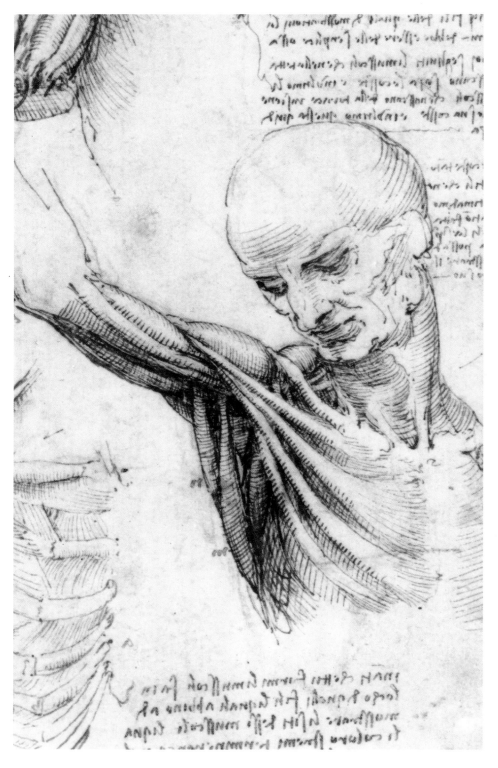

Pursuing the perfect outline is a waste of time. Keep your options open, like da Vinci, by drawing multiple light lines for contours until you acquire the art of judging the placement of the line at the first attempt. This approach of feeling your way not only keeps your work alive, it softens the contours, creating the illusion of roundness and movement. The trick is to vary the intensity of the lines, accentuating them only when you are sure of their final position.

Single, defined, sharp outlines flatten rounded forms, and should be reserved only for abrupt edges. No rubbing out – leave all those expressive lines in! Don't feel threatened by rogue lines; the more dominant ones will keep them in line. Choosing what features of the subject to exclude from your drawing – what to omit – is just as much part of the art as deciding what to include and emphasise.

Leonardo da Vinci, Studies of the anatomy of the shoulder; *detail (see page 103)*

This is an image from a later period (c.1510), when da Vinci introduced the use of curved hatching and crosshatching in combination with straight hatching. The arcs sweeping around the head in this drawing throw the forehead into the foreground.

Light and shade

Darkness, therefore, is the first stage of shadow and light is the last. See therefore...that you make your shadow darkest near to its cause and make the end of it become changed into light so that it seems to have no end.

Da Vinci wrote and illustrated six books on light and shade. The quotation above is a fragment of this wide-ranging research. In order to grade the density of shadows, da Vinci varied the gaps between his hatching lines. The illustration here is based on his research (it has been re-orientated for the right-hander).

Hatching Gaps For Shadows *(2005). Pen and ink. 17 x 23 cm. From da Vinci's 'Studies on the gradation of shadows on and behind spheres', c.1492*

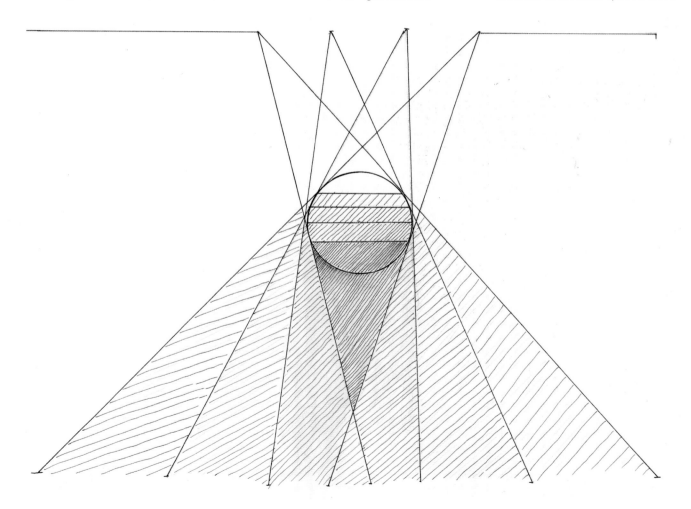

EXERCISE On and off the planet

There is no need to apply perspective when drawing a sphere, because it retains its shape from every viewpoint. The following exercise demonstrates how to convert a circle to a sphere, proceeding clockwise from top left.

1 Draw a circle with an unbroken, unvarying line. This planet is flat, and shows no three-dimensional form.

2 Imagine a source of light shining down from top left. Leave a gap where the light falls. Vary the line so that it is darker and thicker on the shadow side.

3 Use hatching lines to shade on the shadow side of the sphere, following the contour. Leave a narrow edge of reflected light – this enhances the form.

4 Add background shading to put the planet in space and emphasise the reflected light.

5 Add a strong cast shadow, and the planet has landed. To draw like da Vinci, make the cast shadow darkest at its origin against the sphere.

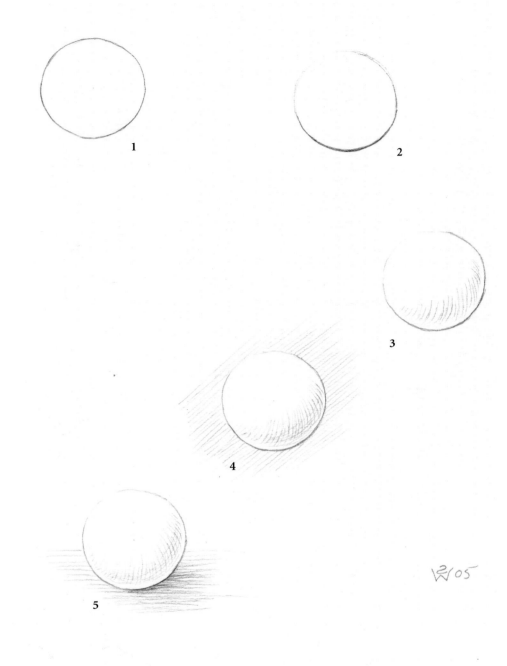

Evolution of a Circle to a Sphere (5 stages)
– Circling the Planet *(2005). 5B pencil. 22 x 20 cm*

By the Light of the Moon *(2005). Pen, ink and giclée. 8 x 16 cm. From da Vinci's 'Studies of the lumen cinereum of the moon', c.1508–10*

By using straight hatching, da Vinci creates a feeling of mystery and great distance. (His hatching lines have been converted for the right-hander.)

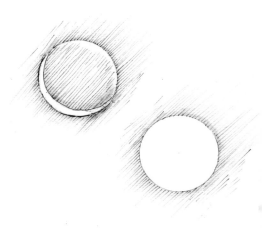

By the light of the moon

This drawing shows da Vinci's use of straight parallel hatching lines. He achieves the effect of a spherical shape by varying the density of shading lines. If he had used curved shading lines to accentuate the roundness of the form, the moon would have leapt forward, appearing like a street lamp. Notice that the moon glows because the paper seems to be a lighter tone when isolated with shading. This optical illusion is used by da Vinci to create highlights without using white chalk.

On edge and hollowed out

Sharp lines are used to draw well-defined edges such as those of rocks, blades, boxes, machinery and the borders of cavities. Unlike a sphere, the edge of the cavity requires a definite, sharp line, especially in the foreground. A rim will require two parallel lines that vary in emphasis. Though hatching lines are used in a similar way to shape the internal surface of a cavity, the shading is darkest at the foreground edge. This gives the sense of the hollow, as shown.

Leaving light between the lines is the trick da Vinci used for shaping in shadows. There is as much shape in a shadow as on an illuminated surface. Filling in a cavity with unvaried shading flattens it, and transforms the hollow into an object. The cavity of a bowl or a box filled in will appear as a lid.

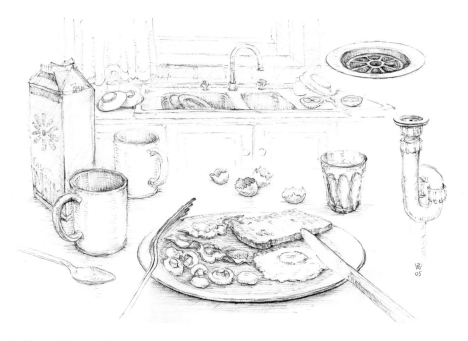

Cavities and Edges in Breakfast Setting, Including Kitchen Sink Plumbing and Hatching Eggs – Left, Right and Centre *(2005). Felt-tip pen, pencil under-drawing. 21 x 29 cm*

Fundamental P's

The seven essentials of drawing:

- perspective
- proportion
- perception
- position
- placement
- planes
- priority

These fundamental considerations remain the same, regardless of style and technique. Naturally inspiration comes first; however, the germ of an idea needs passion to get you motivated. What keeps you going is passion – another P if you like!

Please wait near the armillary sphere

Perspective

Those who are in love with practice without knowledge are like the sailor who gets into a ship without rudder or compass and who never can be certain where he is going. Practice must always be founded on sound theory, and to this Perspective is the guide and the gateway...

Linear perspective

Perspective is the means for creating a three-dimensional illusion on a flat surface. The basic concept in perspective is that people and objects look larger when nearby and become smaller as they recede in the distance, diminishing until they finally vanish. Someone walking away from you soon becomes the size of the tip of your finger. This simple principle of depth and distance is fundamental to the use of perspective. The application of perspective to art and architecture peaked during the Renaissance when da Vinci and his contemporaries mastered it.

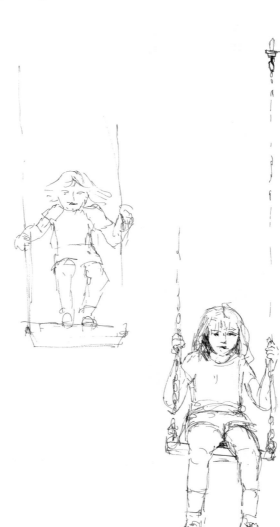

Mind the P's and Queue: Waiting to Use the Perspectograph *(2005). Pen and sepia ink, pencil underdrawing. 29 cm x 28 cm.*

Da Vinci's characters line up to use the perspectograph.

Boys on Swings *(1978). Drafting pen and ink. 37 x 27 cm*

The boy standing on the far swing is smaller and more lightly sketched than the seated boy in the foreground. Keeping the background light and less detailed adds to the sense of distance.

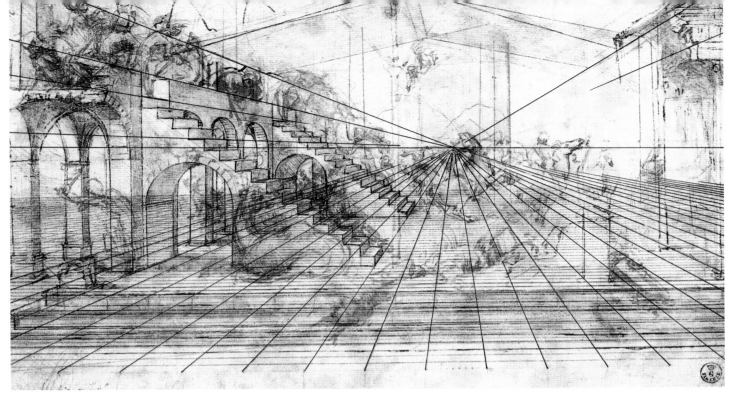

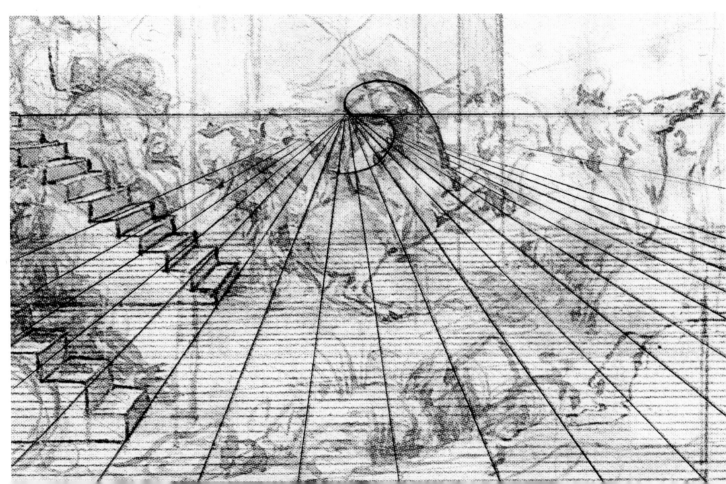

44

Depth and distance

The sense of depth in *The Adoration of the Magi* is remarkable. Its convincing illusion of three dimensions is achieved with linear perspective. Da Vinci allows his imagination to run free by superimposing horses over the perspective lines. Their wild activity is emphasized by the straight, static architecture.

Until you gain a feel for perspective, it is helpful to draw in the *horizon line* (eye level) and vanishing lines.

The horizon line is at eye level when you look straight ahead, with your line of vision parallel to the earth's surface. The horizon moves up with you as you climb a hill, increasing the expanse of the view below. In contrast, when looking out to sea the surface of the ocean between you and the horizon is compressed into a narrow band. When you sunbathe on the beach looking out to sea, the horizon and foreground waves merge together. You would not find our master here where there is a restricted vista – he preferred a bird's eye view!

It helps to imagine that the vanishing point on the horizon is the rising / setting sun, and that the vanishing lines are its rays.

Lines Enhanced with Black Ink in Perspective Study for Background of the Adoration of the Magi *(2005). Drafting pen, black ink, giclée. 12.5 x 22.5 cm*

Notice that the vanishing lines above eye level slope down to the vanishing point, and the ones below eye level slope up and away. The vanishing point is on the horizon at the golden section (see page 52).

Yin and Yang Symbol at Vanishing Point in detail of Perspective Study for Background of the Adoration of the Magi *(2005). Black felt-tip pen, giclée. 14.5 x 21 cm*

The centre of the yin and yang symbol formed by the horse's head and its space is at the vanishing point.

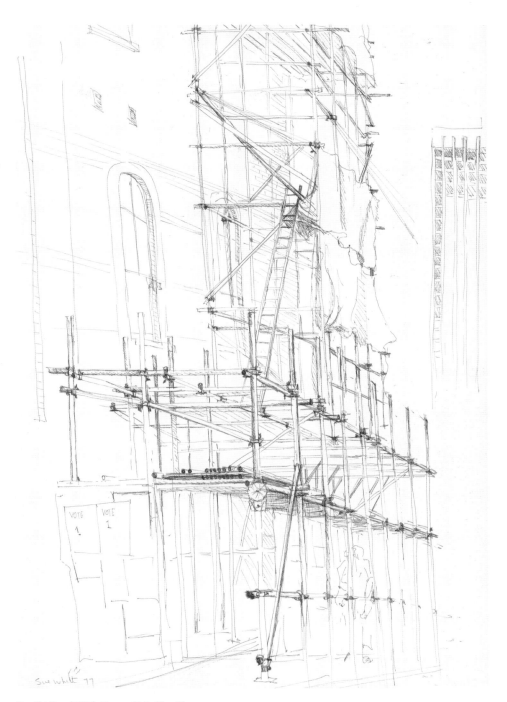

Scaffolding *(1977). Pen and ink, 54 x 37 cm.*

The whole structure is above eye level, so all the vanishing lines converge down and away to the vanishing point (somewhere off the page to the right).

Foreshortening

The illusion of shortening occurs when an object is directed towards you or away from you; this distortion is foreshortening.

Foreshortening is a device for creating drama, movement and depth – there are many examples in da Vinci's work, such as the arm, hand and fingers of the Virgin in the detail shown here.

Foreshortening can be demonstrated by looking end-on at a pencil held directly in front of you and then gradually tilting the pencil so that you see more and more of its length (see opposite page). The actual length is seen undistorted only when the two ends are equidistant from your line of vision. See how a person's arm appears to become shorter as it is raised to point a finger at you.

When da Vinci demonstrates proportion, he draws an unforeshortened view. The arms and legs of *Vitruvian Man* are seen in their full extent.

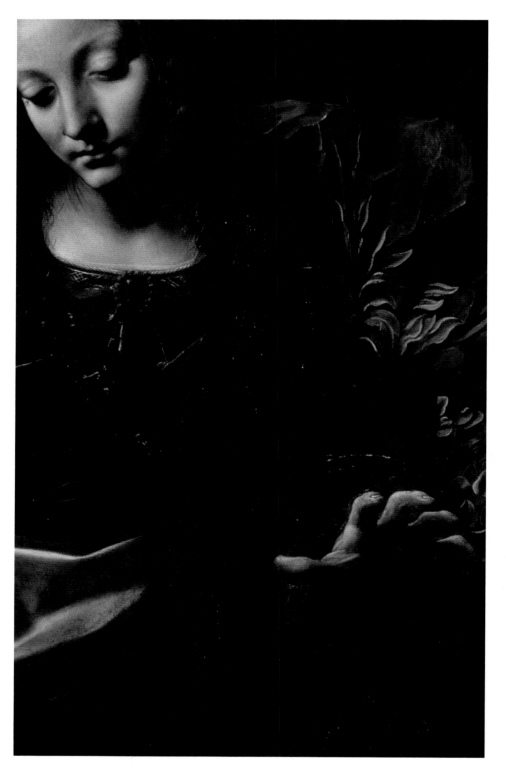

Leonardo da Vinci, The Virgin of the Rocks *(National Gallery version); detail (see page 137)*

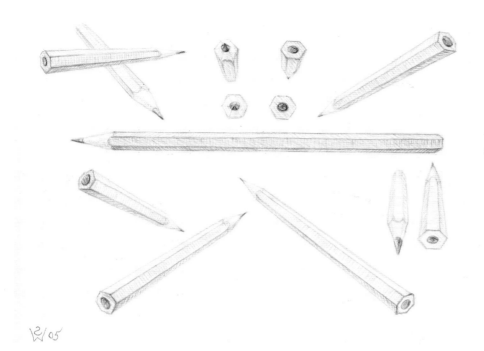

Foreshortening of a Pencil *(2005). Graphite and coloured pencil. 15 x 21 cm*

Drawing Undulations *(2005). Graphite and coloured pencil. 21 x 29 cm*

This shows how to draw foreshortened curves. Looking along a line of hills, they overlap one another as they recede in the distance. Da Vinci's relief maps show hills and valleys that fold like fabric. The ropey muscles of the upper arm overlap in a foreshortened view, in a similar way to a tree's twisting branches when they are foreshortened.

Disc perspective – exercise round the oval

A disc retains its circular shape only when viewed front on. It becomes oval (an ellipse) when viewed obliquely, because its surface is foreshortened. You see a full circle when you spy a coin on the pavement directly between your feet or when you look directly above at a ceiling light or face a fan. The more oblique the viewing angle, the less surface you see. When viewed side-on at eye level the surface disappears altogether, leaving only the edge of the disc in view.

Ellipse Perspective: Coin, Can, Glass *(2005). Waterproof black ink, water-soluble shellac sepia ink, pen and brush. 29 x 21 cm*

Notice that, below eye level, the base of the can (and glass) has a wider ellipse than its top. Conversely, above eye level, the top is rounder than the base.

Ellipse Perspective: Halo from da Vinci's The Annunciation, da Vinci's Gears (inverted), Flying Time *(2005). Pen and ink. 21 x 19 cm*

See how the radiating lines of the halo are shortest in the middle and gradually elongate towards the sides; the same foreshortening principle applies to the numerals on the clock face. Da Vinci drew gears with the light coming from above, and shaded the sides in shadow when the gears were positioned vertically.

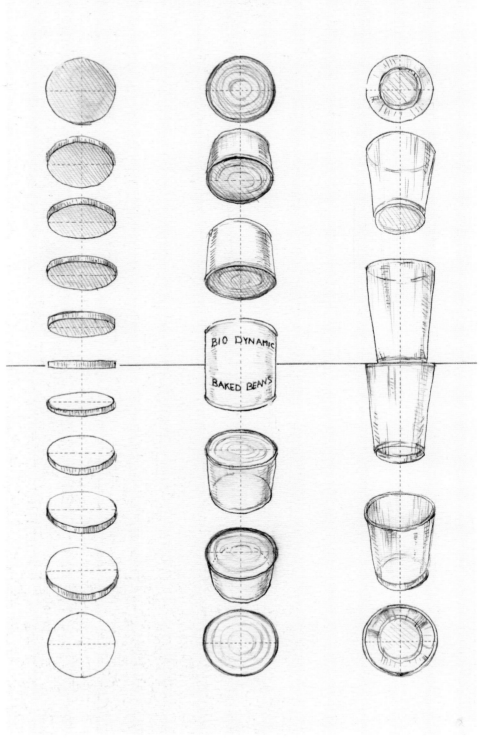

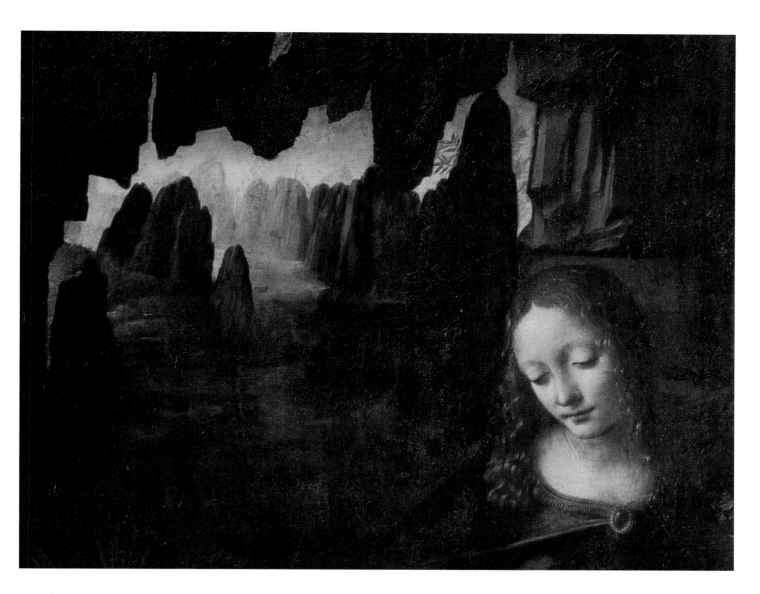

Aerial perspective

There is another kind of perspective that I call aerial... The diminution or loss of colours is in proportion to their distance from the eye that sees them.

Da Vinci coined the term 'aerial perspective' to describe the effect of the atmosphere on distance. Aerial perspective creates the illusion of distance by increasing the blue colours, lightening the tones and making the outlines of distant shapes less defined.

Although da Vinci did not invent the technique, he perfected aerial perspective in the backgrounds of his paintings and his landscape drawings, where he achieves the sense of great distance. Aerial perspective is related to da Vinci's sfumato devices (see page 63).

Leonardo da Vinci, The Virgin of the Rocks (Louvre version); detail (see page 137)

This example of aerial perspective shows the dark brown distinct rocks in the foreground of the landscape, and the gradual change to a pale blue haze in the distance.

Proportion

Proportion was all-important to da Vinci, as can be seen in his numerous studies with manifold division lines. He stated that proportion is one of the foundations of a good drawing. Proportion is about the balance of all the parts to the whole and of the parts to each other.

The spiral form of the horse's forelimb opposite is fundamental to da Vinci's art. It is recognisable in his drawings of hair, water, clouds, gears, engineering springs and in movements. Da Vinci's final abstract drawings are based on helices.

You need to train your mind to be constantly aware of the relationship of the shapes and sizes of the various parts to one another and to the whole. Once the proportions are worked out, details slip into position on your page like a dream. However, if proportion is ignored in the initial stages of a drawing, nothing but confusion and disaster follows. In the construction of a house, the measurements of the walls need to line up with the floor plan – the same applies in drawing.

Measure for measure

To gauge the proportions of an object, use the age-old trick of holding your pencil at arm's length (the arm must be outstretched and kept still). Close one eye; make sure you always use the same eye! For assessing height, hold your pencil point up so its tip aligns with the top of the object. Slide your thumb along the pencil until the thumb aligns with the lower end of the object.

Without moving your thumb, rotate the pencil to a horizontal position while still keeping the arm outstretched. Now you can determine the relative height and width of the object.

Having assessed the overall height against the width, you can gauge more proportions and mark them on your page. Fitting your subject in a box that defines the height and width of your drawing can also be helpful. Da Vinci was fond of using squares and rectangles to assess proportion.

Measure For Measure – Width and Height (2005). Pencil. 21 x 29 cm

Leonardo da Vinci, Measurement of a horse's foreleg (c.1491-92). Pen and ink, black chalk underdrawing. 250 x 187 mm. The Royal Collection © 2006 Her Majesty Queen Elizabeth II

DRAW LIKE DA VINCI | 51

Golden ratio

The part always has a tendency to reunite with its whole in order to escape from its imperfection.

This harmonious proportion permeates da Vinci's work. Related to growth, it can be observed in nature – in the distribution of leaves on a stem as well as in the human body. The golden proportion is also related to the spiral forms of shells and cyclones, and to the curve of a crooked human finger. To appreciate proportion, you need to understand the golden section and its ratio.

The golden ratio is determined on a line by a cut or division point known as the 'golden section'. At this point, the ratio of the length of the shorter segment to the longer segment is the same as the ratio of the length of the longer segment to the length of the whole line. The unaided human eye is instinctively capable of determining this division with remarkable accuracy. The golden ratio is a unique relation between two quantities because it is the only ratio that defines a proportion that does not require three quantities (the third quantity being the sum of the two).

The golden section can be derived by simple geometry from the diagonal of a rectangle composed of two squares. The steps are as follows:

1 Using compass, ruler and set-square, divide the line AB in half, at point C.

2 Drop a line, perpendicular to AB, at B.

3 With compass point at B, inscribe an arc of radius BC to cut the second line at D.

4 Join A to D with a diagonal line.

5 With the point of the compass at D and using the same radius (BC), inscribe an arc cutting the diagonal AD at E.

6 With compass point at A, draw an arc with a new radius AE to cut AB at P. P is the golden section.

Fibonacci series

Fibonacci (1175–1230) discovered that if a series of whole numbers is constructed so that any member is the sum of the two preceding numbers (0, 1, 1, 2, 3, 5, 8, 13…), then the higher any pair of numbers is in the series, the closer their ratio approaches the golden mean. Da Vinci used the satisfying relationships of these numbers in his work.

Polyhedron and Geometrical Bodies (2005). Pen with two tones of black ink. 21 x 15 cm. From da Vinci's illustrations for 'De divina proportione' by Luca Pacioli (1509), a treatise on the geometry of regular solid bodies, architectural forms, the human body and the capital letters of the Latin alphabet.

Compasses Dancing the Golden Section Step: Da Vinci's Brass Compass and Modern Steel Compass in Foreshortened Views (2005). Silverpoint, pen, with white and ochre chalk heightening on faultful matt acrylic ground on cardboard. 16 x 24 cm

Point P is the golden section of the line AB. P divides AB so that AP:PB = AB:AP. An alternative is to use a calculator to determine the golden section of the edge of a page. Its numerical value is close to 0.618, which is about three-fifths. Or simply estimate the golden mean by eye – you will be surprised at how accurate you are.

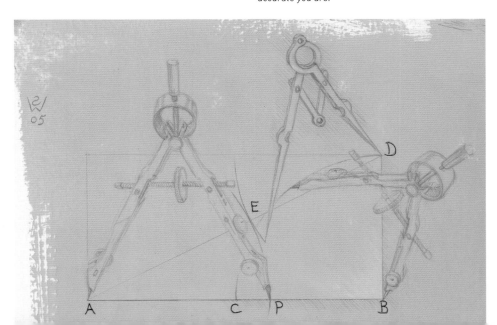

Perception

Show how clouds form and dissolve, how water vapour rises from the earth into the air, how mists form and air thickens, and why one wave seems bluer than another... and how new figures form in the air, and new leaves on the trees...

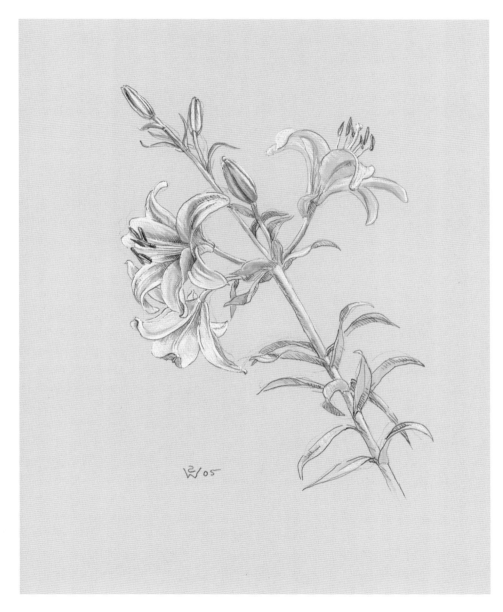

Study of a Hybrid Lily *(2005). Pen, wash, and white chalk on light brown paper. 42 x 30 cm*

Survey the subject from all its viewpoints so that you understand its form. Here, observe that the three inner petals are larger and wider than the three narrow outer ones (sepals). Notice the long central style and the six stamens that circle around it. The head at the end of the style is like a cluster of three beads. The angel in da Vinci's painting 'The Annunciation' is holding a lily stem with buds and blooms.

The quotation gives an insight into da Vinci's passion for everything he drew and painted – perception is motivated by passion. First acquire a thorough knowledge and understanding of the subject you are drawing. This will help your perception of the basic form, the underlying structure, and the visual characteristics.

Da Vinci investigated whatever he drew. Erase from your mind all preconceptions and stereotypes of the subject you are about to draw and analyse it in an objective way as if you were viewing it for the first time. For example, da Vinci recommended drawing the human shoulder from eight different viewpoints. Include written notes as da Vinci did; this enriches your page of studies.

Position

I say that on whichever side the painter places himself he will be well placed if only his eye is between the shaded and the illuminated portions of the object he is drawing; and this place you will find by putting yourself between the point [of light] and the division between the shadow and the light on the object to be drawn.

When you have to draw from nature, stand three times as far away as the size of the object that you are drawing.

Position yourself at a suitable distance from the subject. When drawing a full figure you need more distance; for a flower study or a pea pod, one arm's length is sufficient. Choose a view of the subject that interests you and demonstrates its characteristics. If you can, arrange the subject to the best advantage. A foreshortened view distorts proportions; however, foreshortening is dramatic and emphasises depth and movement. Have your drawing board or sketchbook directly in front of you, so that you face your subject square-on for assessing angles, directions and proportions with your pencil held at arm's length.

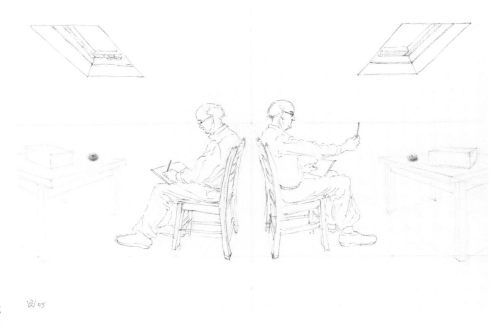

Back-to-Back, Left- and Right-Handed in Attic: Drawing Position According to da Vinci's Instructions *(2005). Pen, coloured pencil, graphite underdrawing. 21 x 29 cm*

Placement

Placement is the art of Feng Shui on the page. Placement is critical, especially if you are making a compositional study.

First, work out whether your view of the subject is higher than it is wide, or wider than it is high. Landscapes are usually horizontal, portraits vertical. Make a rough assessment of where the centre of the subject is and mark it on your page. Place the subject's centre near the middle and / or golden section of the page.

Mark the outermost boundaries of the subject and keep your drawing within these limits. Scale the size of your subject to suit the size and shape of your paper, maintaining the overall proportion.

Even when making a rough sketch (when placement is not of concern), you still need to consider size so that your sketch does not run over the edge.

Baroque Violinist – Stephen (2001). Drafting pen and ink. 28.5 x 21 cm

The bow plays on the strings at the golden section, and the figure is placed off-centre to allow space for the direction of the action. The corners of the music stand direct the eye of the viewer back to the violinist. Avoid drawing details at the edge of a page – allow your lines to fade away at the boundaries.

Stephen in 'Mixed Doubles'
Canberra 7 July 2001

Planes

Planes are assessed as imaginary in the same way as vanishing lines. They are the surfaces of the subject that can be inclined, horizontal or vertical.

While the top of a table lies in the horizontal plane, its legs are in a vertical plane. An escalator is in an inclined plane. Various planes can be distinguished from each other by parallel hatching in different directions, or by leaving an area unshaded.

Irregular forms have numerous planes. Even the rounded surface of a banana has flatish areas. Varying planes on the surfaces of a leaf, chocolate and crinkled wrapping paper are distinguished in the drawing here by changing the directions of hatching.

When drawing shadows cast by an object, use horizontal hatching as shown in the horizontal plane of the table. The shine of aluminium foil is achieved by isolating it from the surrounding paper by shading (as described on page 41).

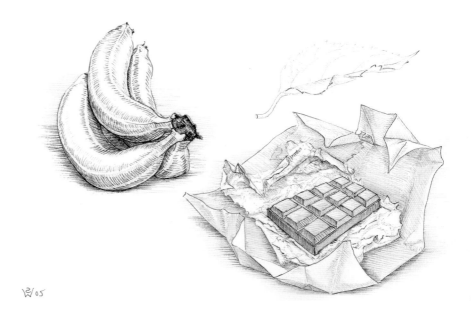

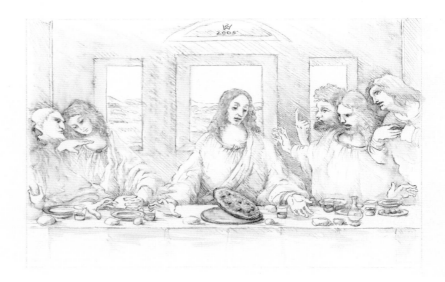

Bananas, Chocolate, and Leaf: Hatching to Indicate Planes *(2005). Pen and light brush wash. 21 x 29 cm*

A Pizza on the Wrong Plane in the Wrong Millennium *(2005). Calligraphy pen, sepia ink, wash, coloured pencil. 21x 29 cm*

Priorities

Getting your priorities right is the art part. Just as important as choosing what to include is selecting what to leave out. All parts must relate in harmony with the whole. The arrangement of space is equally important and should always be considered in relation to the forms.

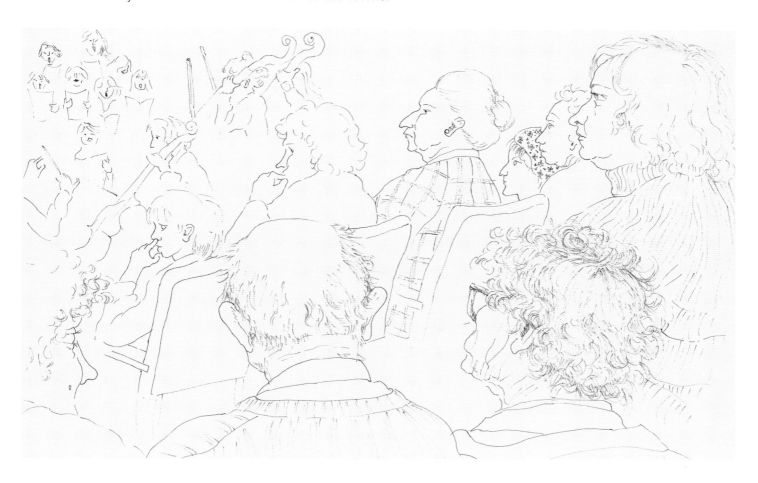

Da Vinci's drawings have the magical balance that is explained above – this is the fundamental quality that distinguishes him as a master draftsman.

Work out the hierarchy of importance of the features. Emphasise the most expressive; then de-emphasise or even omit those that are insignificant. In da Vinci's drawings of faces, for example, he reserves his darkest lines for the most expressive facial features and for the foreground.

Parents at a School Concert (1979). Drafting pen. 27 x 37 cm

Detail is in proportion to distance – as the figures come closer, the amount of detail drawn increases. The hair and wrinkles of the grandparents contrast with the singers' faces in the background, that are merely suggested. The child picking its nose in the middle distance is sketched in intermediate detail.

Putting the Seven P's into Practice

The following exercise puts the P's (perception, position, placement, perspective, proportion, planes and priority) into practice and explains the use of secondary vanishing points required to draw boxes, books, tables, buildings and so on.

Exercise: Drawing a box of peas

Begin with a dry drawer (charcoal, chalk or pencil), as da Vinci did for rough underdrawing.

PERCEPTION. Consider the structure and shape of the box you are about to draw. (In the example here, the box contains peas with an expiry date when Leonardo had to leave Milan with his friend Luca Pacioli, following the capture of Ludovico Sforza by the French!)

POSITION. Following da Vinci's advice on page 54, position yourself and the box. Arrange the box to show its shape and characteristics to the best advantage, with one corner closer to you so that the two edges of the base are at differing angles. The closer you are, the more difficult it becomes to assess proportions and perspective.

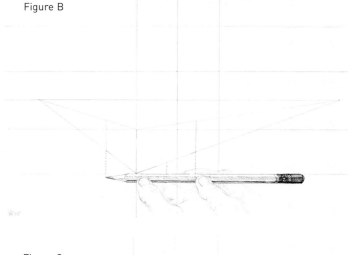

Figure B

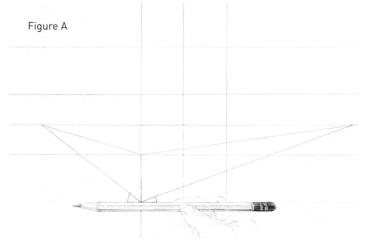

Figure A

Figure C

Drawing a Box of Peas Destined
for the Sforza Castle, Milan, Expiry
14 December 1499 *(2005). Graphite
pencil underdrawing, drafting pen,
green pencil. 21 x 29.5 cm*

*Figure A: perception, position,
placement and perspective*
Figure B: drawing proportion
Figure C: drawing planes
Figure D: decisions concerning priority

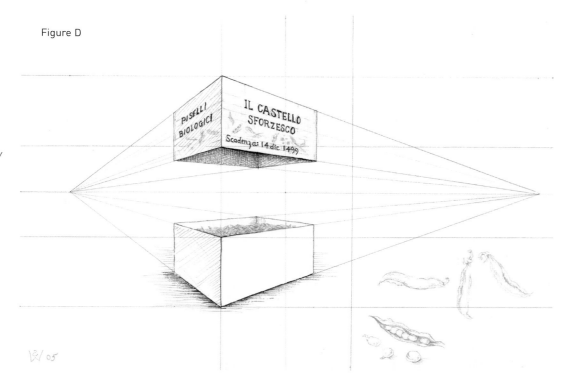

Figure D

PLACEMENT. First determine the relative height and width of the box, as described on page 50. This box is wider than it is high, so orientate your page to landscape format. The box is below eye level and close to you, so position it in the lower half of the page. Find the centre of the page by drawing vertical and horizontal midlines (shown in Figure A). If you wish, divide the page further into golden sections (da Vinci used such divisions for *The Last Supper* composition). Draw a horizontal reference line in the lower section of the page (corresponding to the position of the pencil in Figure A). Now draw in the vertical edge of the box nearest to you, at about the golden section, so that it touches this reference line.

PERSPECTIVE. Use the horizontal mid-line as your eye level / horizon line. All the vanishing lines will converge upwards, because the box is below eye-level. Hold your pencil in a horizontal position, and line it up with the tip of the lowest point of the box. Your eye automatically picks up the angle between a base edge of the box and the pencil (see Figure A). You can now confidently draw the oblique line of the edge of the box at the correct angle (with respect to your horizontal reference line). Repeat this for the other base edge of the

box. Extend both these baselines to meet the eye level / horizon line at the two secondary vanishing points.

PROPORTION. You have already determined the overall height to the width of the box. Now gauge the sides of the box, by sliding your thumb along the pencil as illustrated in Figure B. Draw in the vertical edges of the box at the other two corners.

PLANES. Draw in the top edges of the box along the vanishing lines (Figure C). Notice that the top of the box is on a less inclined plane than the base.

PRIORITY. Now tackle the details and shading (Figure D). This is the art part, where you choose your hierarchy of emphasis. Strengthen the edge of the box closest to you; grade lines into the distance; shade according to previous instructions. Lightly suggest pea pods in the box, without undue emphasis (texture is the last priority). Draw the lid in the space above the box in an exploded view (da Vinci invented this device – see page 110). A challenge is to label the lid with letters in perspective.

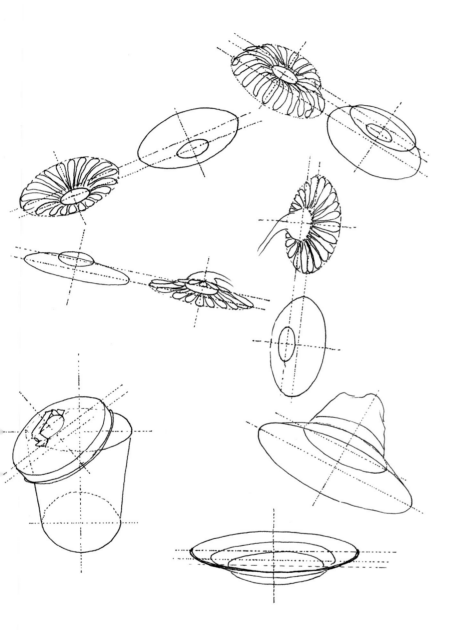

What's for breakfast?

Draw an arrangement on a table of what you have for breakfast. You could include a mug, foreshortened fork and spoon, grapefruit, bowl and eggs (no bacon – our master was vegetarian!). Use your preferred medium; you could try silverpoint. Before commencing, remember to take many breaks from drawing to refresh your mind, as our master advises:

Uncle Ted Eating Breakfast *(1975).*
Pen and ink. 24 x 26 cm

Ellipses and Planes in
Foreshortening *(1989). Pen*
and ink. 29 x 21 cm

This is an example of a deadly
diagram, stiffly drawn with no free
lines, in contrast to the free-hand
drawing beside it. Foreshortening of
multiple ellipses is demonstrated,
in flowers, a hat, a garbage bin and
a plate. Each ellipse is on a different
parallel plane.

Every now and then go away and have a little relaxation, for when you come back to your work your judgement will be surer. Go some distance away because then the work appears smaller and more of it can be taken in at a glance and a lack of harmony and proportion is more readily seen.

Da Vinci realized that the mind is not capable of continuous application and intense concentration, and that it needs a break from time to time.

Allow the Tea to Draw: Silver Teapot (2005). Silverpoint, white chalk and some scalpel scraping on gesso board prepared with green acrylic washes. 30 x 22 cm

Sfumato – chiaroscuro

The Italian words *chiaroscuro* and *sfumato*, used to describe da Vinci's distinctive style, are sometimes confused – chiaroscuro means bright–dark and sfumato means soft or mellow.

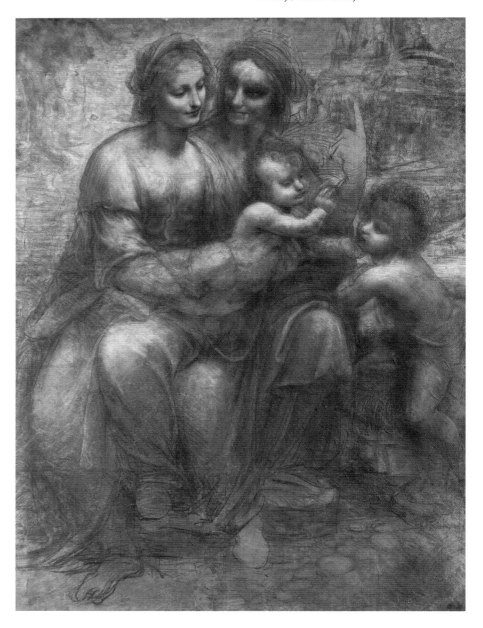

Leonardo da Vinci, Cartoon for the Virgin, Child, St Anne and St John *(c.1505–07). Charcoal, soft black chalk, highlighted with white chalk on light-brown tinted paper. The Art Archive / National Gallery / Eileen Tweedy*

Chiaroscuro: tone alone

The word 'chiaroscuro' was coined long after da Vinci's time, to describe the painting style of da Vinci, Caravaggio, Rembrandt and others. Da Vinci's style differs fundamentally from these artists, who emphasized heavy cast shadows with dense, dark backgrounds. Da Vinci preferred a diffused natural light that allowed the subject to emerge from a soft blend of light and shadow, without the interference of harsh cast shadows that dominate. He placed his subjects in a cavernous setting or on top of the world with a vast depth of light that illuminated from the background rather than the foreground. This threw the subject forward in a convincing three-dimensional illusion.

Sfumato

Da Vinci coined this term for the painting technique where changes in colour or tone are so gradual that the transitions are imperceptible. Da Vinci fused the transition between different colours and tones so that the gradations became invisible, as in a hazy, smoky atmosphere.

Understanding tone (light and shade) is the key to successful sfumato. Da Vinci developed a unique sfumato technique for both painting and drawing, using shading lines to draw atmosphere over contour lines.

The art of drawing sfumato tomatoes

Drawing a tomato is an excellent prelude to drawing human flesh – the tomato flesh has similar consistency, contours and translucency. The application of tonal variations and highlights will therefore be much the same (with more sheen on the tomato) and will enable you to master the shading of flesh without concern for human expression or movement, or what might be making the subject blush!

The model in these drawings is an ox heart tomato, chosen for its sensuous folds and bulges. It is the shapeliest variety of tomato and mimics da Vinci's drawing of a baby's leg flexed at the knee. (A smooth variety is just as good for this exercise.)

The three step-by-step exercises build up from using monochrome to full colour. These instructions are suitable for drawing any subject in pastel, chalk or conté – simply adapt the procedure and change the range of colours used. You can experiment with modifying the colours of the tomato flesh to that of the human, remembering that da Vinci subordinated colour in favour of emphasising depth and form. Notice how the fully coloured drawing of the tomato lacks the depth of form of the tomato drawn with limited colours.

Leonardo da Vinci, Studies of a Naked Infant; *detail (see page 98)*

EXERCISE 1 **Monochrome sfumato tomato**

You will need:
- 2B to 4B pencil
- hard white chalk pencil or white charcoal
- toned paper (or brown paper)

1 Perception. Study the form of the tomato.

2 Position the tomato on a table in relation to the light from a window (as on page 54). If this is impractical, place a light source above and to one side of the tomato. Tilt the navel of the tomato towards you.

3 Placement. Since the tomato is below eye level, position it in the lower region of the page, using golden section and symmetry.

4 Perspective. As the tomato is below your eye level, all vanishing lines slope upwards on the page (to the eye level above the tomato). Apply the perspective of ellipses. Make a rough sketch on toned paper. Note the lowest point on the tomato and draw a horizontal line to help ascertain the shape of the base curves.

5 Proportion. Assess the height to the width with a pencil held at arm's length, as on page 50.

6 Planes. Suggest the position of the disc of the tomato's navel in relation to the contour of the whole tomato. This is a crucial step, so take your time. Sketch in the oval shape first, then the little triangles with their points that coincide with the grooves in the flesh between the segments. Leave the paper showing through in the centre of the navel.

Now sketch in the lines of the grooves that radiate from the navel. The alternating grooves and crests are prominent where they merge to gather round the navel, and tend to flatten as they fan outward across the flesh. The crest of the fold closest to you may partially obscure the hollow of the navel; this feature helps to indicate form.

Shade the base of the tomato, as for a sphere (page 40). Leave an edge of reflected light where the tomato sits on the table.

Draw in the cast shadow on the table using straight parallel lines (horizontal or at angle corresponding to the rays of light). Remember that shadows do not have edges; never outline cast shadows otherwise the shadow will take on form. The intensity of shading in the whole drawing is darkest in the cast shadow where the tomato contacts the table, so bring the darkest shading flush with the line of the edge of the tomato. Grade the shading as described on page 40.

7 Priority. Now you need to establish the hierarchy of white highlights. Use white highlight sparingly and with gradations of tone, otherwise your tomato will look as though it has been sprayed with pesticide. The gradation of tones should relate to the

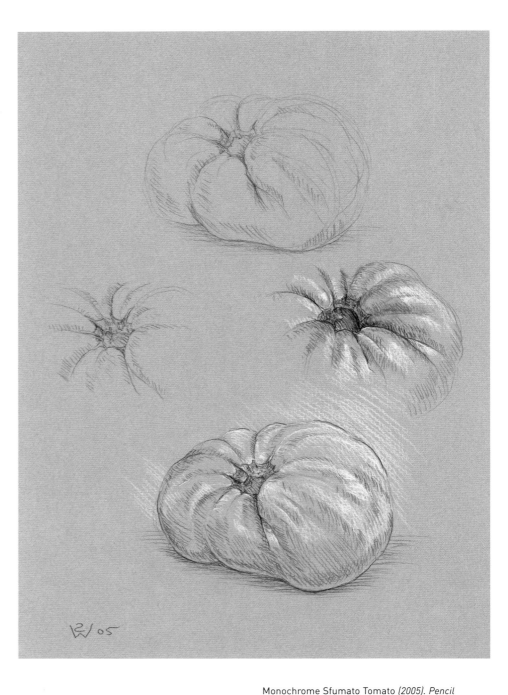

Monochrome Sfumato Tomato *(2005). Pencil and white chalk on blue toned pastel paper. 37.5 x 27.5 cm*

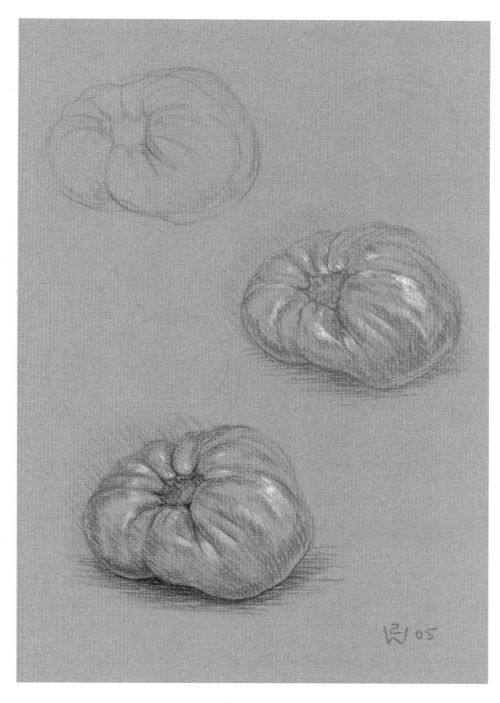

Three-Colour Sfumato Tomato *(2005). Black, white, and red chalk on red-ochre Ingres paper. 32.5 x 24.5 cm*

light falling on the form. Each highlight has its own intrinsic shape, as with shadows.

To create depth, the highlights on the tomato's far side should be feint suggestions, several tones darker than stark white. This makes the far side fade into the background. Reserve the highest intensity of highlight for the spot where the light from the window falls. Never use white for reflected light on the surface in the shadow, as reflected light is never as intense as direct light.

A few feint shading lines in the background behind the tomato (the side away from the light) gives a three-dimensional effect. Suggesting some of these lines across the tomato where it catches the light creates a misty effect in the atmosphere (sfumato).

EXERCISE 2 **Three-colour sfumato tomato**
Just as da Vinci did, use red colour on red-toned paper (of a lighter tone) to achieve a sfumato effect from the start.

You will need:
• red-toned pastel paper
• pastel chalk or conté in three colours (such as red earth, black and white)

1 Sketch the outline of the tomato, its navel and its grooves in red earth.

2 To shape the tomato, shade with red earth and add white highlights, as in Exercise 1.

3 Add black chalk for the cast shadow on the table beneath the tomato. Use black to shape the contour of the folds around the navel, as in Exercise 1. Lightly shade with black next to the edge of the reflected light on the tomato – using black to shade the tomato anywhere else will make it rotten!

EXERCISE 3 **Fifteen-colour sfumato tomato**
The same principles of gradation shading apply when drawing with multiple colours. This is an exercise in drawing in colour, not colouring in. (Colouring in stunts a child's creativity – the kid that runs the colour beyond the outline, merges colours at boundaries, and leaves gaps unfilled is already employing sfumato techniques!)

Make a selection of colours, particularly the reds, oranges and pinks of tomato flesh. The skilled artist can achieve a convincing tomato by blending a few basic colours – yellow, red, maroon, pale blue, black and white. Combining basic colours makes additional shades. Yellow streaked with red makes orange; white with black, a cool grey, white with red, pink; and white, blue and red make mauve. These interweaving colours glow and vibrate; but the effect is lost if they are filled in on top of each other.

You will need:

• pastels, pastel-chalks and conté
• a reddish toned pastel paper

1 Separate your colours into two lots – warm (yellow, orange, pink and red hues) and cool (green, blue, mauve and violet).

2 Lay the warm and cool colours out in two rows, grading them from the lightest to the darkest tones. The intensity of the hues is enhanced by pitting against each other the colours that lie adjacent on the spectrum, such as yellow next to orange, then orange next to bright red, and bright red next to deep crimson. Colours of the same tone such as orange and pink vibrate next to one another.

3 Follow the steps in Exercise 1, sketching the tomato first in pencil or a colour (such as maroon), and lightly outline the navel. Begin to apply colour by drawing with the paler shades first – orange on the crest of the folds, and pink highlights next to orange where the light catches.

Allow the drawing to emerge gradually by applying colour with a light touch at first, then building up the hues to full strength. Keep varying the colours, and blend the coloured lines in a feathering fashion where they meet to create a sfumato effect. Refrain from deadening the colour by applying one on top of another. A mid-pink (the same depth of tone as the paper) will give the electric effect suggested here in the background on the side away from the light.

4 The innate colour of a subject is purest on the surface just where the light changes to shadow. Apply intense red here. Where the light falls on the tomato, merge orange with pink. In the shadows, merge deep red with maroon. If your drawing looks more like tomato soup, begin again on the same page; this is what da Vinci would have done, repeating it until he was satisfied. Add some detailed studies of the navel area.

5 Use highlights sparingly. Notice that they vary in colour and intensity. Natural light indoors is cool (mauve or blue); use touches of mauve highlights on the side of the tomato in the background, keeping pure white for the foreground spot of light from the window. As described in Exercise 1, step 7, the lightest tone should be reserved for the highlight in the foreground. Leave a line of reflected light at the edge of the tomato on the shadow side.

The darkest area of the whole drawing is the shadow beneath the tomato where it sits on the table. Grade this from black to maroon. Add a touch of deep red for the reflection from the tomato to liven the cast shadow. Gradually lighten this cast shadow with deep pink until the shadows are lost in the tone of the paper.

6 To draw the navel, blend a touch of orange and white with the black; this will give the effect of a green tinge. Use light pink for the edge of reflected light, and for the highlights on the crests of the folds in the background.

7 Notice how the shape of the window's reflection in this tomato follows the curve of its surface. To draw the light reflection, use a spot of white surrounded by mauve blended with white.

15-Colour Sfumato Tomato *(2005). 15 pastel chalks on red-ochre Ingres paper. 32.5 x 24.5 cm*

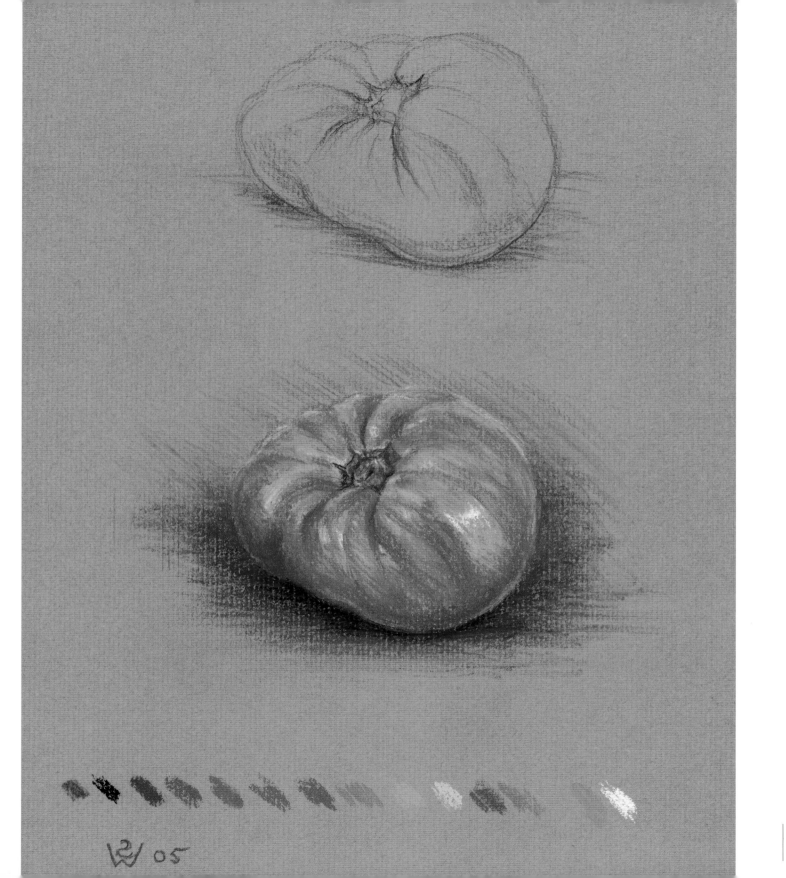

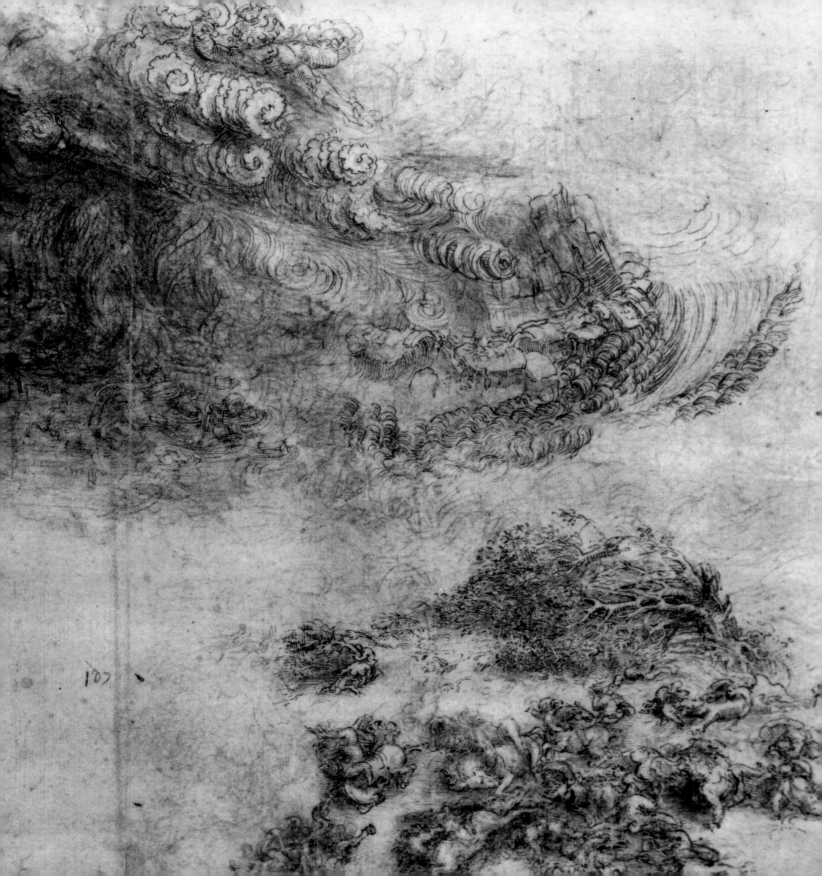

DRAWING DA VINCI'S DIVERSE UNIVERSE

A selection from da Vinci's vast œuvre of drawings is discussed in this section – animals, plants, landscape, natural forces, flow of water and blood, inventions, weaponry and architecture.

The 12-volume *Codex Atlanticus* alone contains a wealth of drawings of animated inventions, engineering and machinery. Among them are hydraulic devices, designs for excavation equipment, mechanisms for clocks, designs for irrigation channels, a revolving crane, a drive mechanism for a potter's wheel, an automobile, plus all sorts of springs, chains, gears, cogwheels, winches, and even the mechanism of a keyboard musical instrument.

Leonardo da Vinci, Hurricane over Horsemen and Trees; detail (see page 85)

Animals and animated inventions

Among the variety of animals that da Vinci drew are dogs, cats, bears, oxen, donkeys, sheep and ermines, as well as prolific studies of horses. Many of his animal studies are for paintings. He admired birds above all creatures and studied them in his passion for flight and flying machines; our master set caged birds free!

To draw animals, analyse their proportions and study their legs in particular. Da Vinci's proportional drawing of the leg of a horse (page 51) shows his thoroughness in studying an animal. He wrote:

Compose roughly the parts of your figures and attend first to the movements appropriate to the mental states of the creatures composing your narrative.

Here da Vinci is applying perception (the first of our P's).

Double Dog and Bell *(2005). Two tones of red chalk, brush, touched with black chalk. 14 x 16 cm*

Chalk, conté and pastel are suitable for drawing animal fur. This drawing follows da Vinci's technique of using different coloured earth-red chalks on red-toned paper. The proportions of the head are marked in first. A light wash is added here and there by picking up the pigment on the page with a damp brush. Lastly, the eye and mouth are emphasised with a touch of black. Notice the bell in the space between the shallow curves of profiles in the two heads, and the long bridge of the nose indicated by da Vinci's proportion lines.

Pepper June 97
LSW

Pepper's Snout and Paws (1997).
Drafting pen and brush wash. 21 x 14 cm

Drawing the extremities only of an animal
or a person, so that the head and limbs
emerge from the edge of the page,
creates mystery. The viewer's imagination
is stimulated to expand beyond the page
to complete the image. To draw animal
fur, suggest it with a few lines rather than
drawing a maze of hairs. The directions of
the underlying bones and muscles can be
indicated by occasional lines and shading
between the fur. Avoid the tendency to fill
in the paw pads – filling in, like colouring
in, flattens shapes. Treat the rounded
pads with the full range of tone.

Horse drawn

For transport, power and battles, the horse was all-important during the Renaissance, as is evident in da Vinci's art. He made numerous detailed studies of horses and their proportions – for paintings, such as *The Battle of Anghiari* and *The Adoration* of the Magi, and his only sculpture, *Il Cavallo.*

Da Vinci worked for sixteen years on the *Il Cavallo* project for a 7.2 metre-high bronze horse for the Duke of Milan. The horse was so enormous that a radical new method was needed for its casting. Da Vinci's grasp of bronze casting technology is shown here – he illustrates and writes instructions for casting the horse upside down. The vertical lines are the feeder tubes for the molten bronze. He sculpted an earthen (clay-based) model, but sadly this one sculpture of da Vinci's was never to be – the invading French destroyed the model. The moulds for the casting are lost.

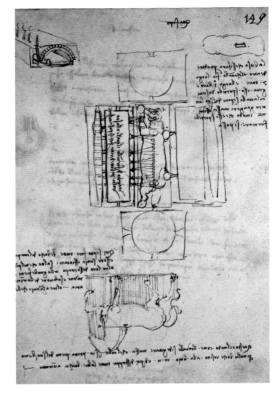

Leonardo da Vinci, Studies of an Air Screw, *enabling vertical flight (1487–1490). Pen and ink. 232 x 165 mm. The Art Archive / Paris Bibliotheque*

This drawing in particular shows da Vinci's awareness of air, which he drew with as much consideration as solid forms. Da Vinci drew many elaborate inventions with bird- or bat-like wings. This machine is different from the rest; it has an astounding resemblance to the principle of a modern helicopter.

Leonardo da Vinci, Sketches for the casting of the horse monument *(c.1493). Pen and ink. 210 x 144 mm. Media, dimensions. The Art Archive / Biblioteca Nacional Madrid*

Leonardo da Vinci, A Scythed chariot, 'armoured car' and pike *(c.1487). Pen, ink and wash. 173 x 246 mm. The Art Archive / British Museum / Eileen Tweedy*

Employed by Ludovico Sforza and Cesare Borgia as a military engineer, da Vinci designed toys for the boys. Here da Vinci combines imagination with phenomenal skill in drawing horses, demonstrating his masterful technique with pen and ink, and brush wash. He employs straight horizontal hatching in the back-ground to emphasise movement in the curved contours, straight diagonal hatching for the form of the horse, and his unique sfumato hatching in the clouds of dust.

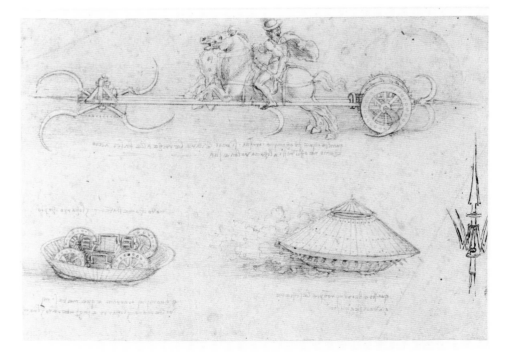

Air and flight

I think, if this screw instrument is well made, that means, made from linen starched (to block its pores) and is turned rapidly, the said screw will find its female in the air and will climb upwards.

Da Vinci's sense of the balance between male and female, yin and yang, is expressed in both his art and writing. In his studies of flying birds, he includes not only the intricate changes in the direction of their wings, but also the air currents. He drew many types of screw shapes in machinery, clouds, water and hair.

Unregistered Vehicle – Get with the Times! (2005). Calligraphy pen and ink, wash, blue and black ballpoint, coloured pencil, correction fluid. 21 x 29 cm.

The automobile in the foreground is after da Vinci's drawing (c. 1478) now in the Codex Atlanticus. His 'Pleasure and Pain' direct the traffic.

Architecture

An arch is nothing other than a strength caused by two weaknesses; for the arch in buildings in made up of two segments of a circle, and each of these segments being in itself very weak desires to fall, and as the one withstands the downfall of the other, the two weaknesses are converted into a single strength.

Da Vinci designed arches to solve the problem of the cupola for the Milan cathedral. Drawings of arches and stairs are prominent in *The Adoration of the Magi.* Unfortunately, da Vinci's architectural designs never went beyond the drafting stage. The striking octagonal floor plan below is one of many of da Vinci's circular designs with eight pillars.

Steps in DNA

It is believed that da Vinci designed the double helix stairs in the chateau at Chambord, France, near where he spent the final years of his life. The stairwell has a central pillar, eight external supporting pillars and two separate entrances at ground level. People on one set of stairs never pass those on the other.

Blueprint – da Vinci's Eight-Sided Temple Plan *(2005). Graphite pencil and blue coloured pencil. 12 x 12 cm*

Double Helix Staircase *(2005). Graphite, blue and pink coloured pencil. 22 x 14 cm*

Two sets of stairs spiral around a central pillar. The eight outer pillars are not included here so that the helices are visible.

Draws shoots and leaves

First be sure you know all the members of all the things you wish to depict, both the members of animals and the members of landscapes, that is to say, rocks, plants and so forth.

Observing da Vinci's approach

Our master draws *in situ* a gracefully curving branch of blackberry, weighed down with fruit. It emerges from the background in its natural environment rather than in an artificially arranged upright position indoors. Da Vinci applies aerial perspective to distinguish the five branches in the foreground from the five in the background that are lightly suggested, creating the illusion of distance.

The air in the spaces is hatched in every direction, with cross hatching between the densest parts of the foliage. He applies his masterful skills in light and shade, reserving the strongest lines and white heightening to shape the berries and leaves in the foreground.

The lowest branches of the trees that have big leaves and heavy fruits…always bend towards the ground.

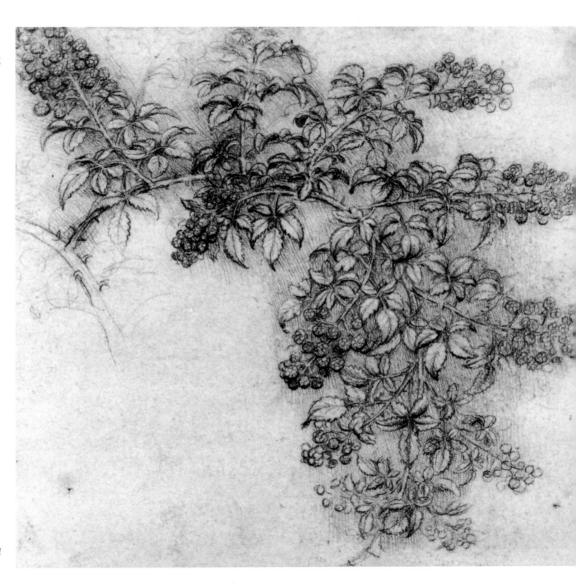

Leonardo da Vinci, Shoot of blackberry (bramble), *(c.1505–07). Red chalk with touches of white chalk on pale orange prepared paper. 155 x 162 mm. The Royal Collection © 2006 Her Majesty Queen Elizabeth II*

EXERCISE Drawing a bough of fruit

1 Select a fruiting bough to draw *in situ*. Chose a view with a strong diagonal curve.

2 Begin by indicating the diagonal of the main branch, placing it on your page to suit the format. Then draw in the curve.

3 Assess height and width. Mark in the edges of the form, leaving ample margin.

4 Start to draw the branches very lightly, so that you can place leaves and fruit in front of them.

5 Add details to leaves and fruit in the foreground. Emphasise the edges of the leaves closest to you with strong sharp lines to give a three dimensional effect. Use white heightening sparingly and only where the light falls in the foreground.

Lilli Pilli Branch *(2005). Red pastel chalk with touches of white pastel chalk on buff-toned pastel paper. 29 x 36 cm*

Leda Has a Bad Hair Day – Star of Bethlehem Plant *(2005). Black pen and red chalk. 29 x 21 cm*

Growth is a twisting, spiralling movement that da Vinci emphasised in his drawing of the Star of Bethlehem Plant. The leaves of da Vinci's plant resemble waves of water with undercurrents or a whorl on the crown of a head – Leda's got the whole world in this whorl even if she is having a bad day!

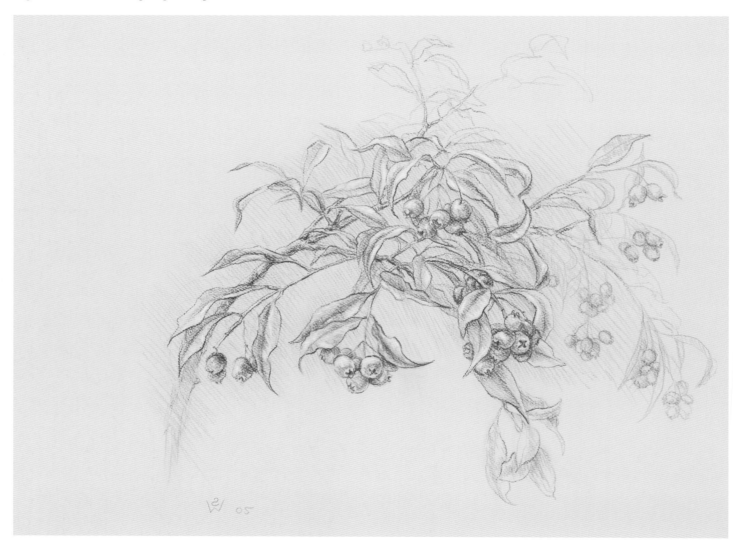

Exposed to the elements

Da Vinci drew the movements of nature and their spiralling forms.
He saw the similarities between the shapes and patterns of curves
in locks of hair, flowing water, and the blood in the heart. Practise
drawing spirals, vortices and double helices while doodling.

*Observe the motion of the surface of water,
which resembles the behaviour of hair, which
has two motions, of which one depends on
the weight of the strands, the other on the
line of its revolving; thus water makes
revolving eddies, one part of which depends
upon the impetus of the principle current,
and the other depends on the incident and
reflected motions.*

Observe the flowing patterns of single
and double helices, inverted screws and
vortices in da Vinci's drawings of blood,
hair and water. There are loads of these
codes in Leda's hair (opposite).

Late in his life, da Vinci undertook
extensive research into the structure of
the ox heart. He drew the vortices in the
blood flow leaving the heart according to
his observations on water currents, and
explained the closure of the cusps of the
heart's outflow valves as the result of forces
in the eddy currents.

Leonardo da Vinci, Studies of the vortex motion of
blood within the heart *(c.1513). Pen and ink on blue
prepared paper. 283 x 207 mm. The Royal Collection
© 2006 Her Majesty Queen Elizabeth II*

Leonardo da Vinci, A Seated old man; water studies; *detail (see page 9)*

Da Vinci wrote: 'Water is the driving force of all nature'.

Leonardo da Vinci, Study for the head of Leda *(c.1505-7). Pen and ink over black chalk. 198 x 166 mm. The Royal Collection © 2006 Her Majesty Queen Elizabeth II*

Seeing the wood for the trees

This drawing of a copse of trees is a brilliant composition. Why did da Vinci confine the group of trees to the top corner of the page instead of placing them in the middle or near the base of the page? The answer is that da Vinci is using a clever device for creating depth. By leaving a large area of space on the page below the copse, he creates the illusion that the trees are a long distance away. You feel you could walk from the bottom of the page across the space and meander among the trees. Japanese woodblock artists and 19th-century French masters used this compositional device.

The trees appear to be their natural size because of the distance. If they were positioned near the base of the page they would be brought to the foreground and reduced to a cluster of bonsai! It is a shame that this drawing is often cropped in books.

Expansive landscape

Da Vinci's pure landscapes would have been unique at the time, as landscape was not part of the European cultural tradition in the 15th century. His earliest known drawing is a little Tuscan landscape sketch dated 1473. This sketch represents a turning point in the history of occidental art. Da Vinci's landscapes from a bird's eye view remind us of the ancient oriental (Chinese) scenes, where humankind is insignificant compared to the vastness of nature.

Leonardo da Vinci, A Copse of Trees *(c.1500). Red chalk, 194 x 153 mm. The Royal Collection © 2006 Her Majesty Queen Elizabeth II*

The roots of trees thrusting their way through stratified rock in the escarpment of this landscape bear a striking resemblance to the fragments of da Vinci's tree roots in the underdrawing of the wall of the Sala delle Asse in Milan, which were revealed in a 1956 restoration.

Leonardo da Vinci, River running through a rocky
ravine with birds in the foreground *(c.1483)*. *Pen
and ink. The Royal Collection © 2006 Her Majesty
Queen Elizabeth II*

*Following the steps of the exercise described on
the following pages, you could try to convert this
composition to the Grand Canyon (or your favourite
gorge) by making changes to the details and by
applying da Vinci's techniques in aerial perspective.*

Above the world with da Vinci

It is extraordinary that da Vinci could imagine and draw a vista above the clouds that we take for granted from an aeroplane seat. The entire view is below eye level so the horizon line is off the top of his page – this is apparent because the cones of the most distant mountains are tilted forward.

This drawing is a dynamic drama that pre-empts the compositions of da Vinci's last period. Notice (i) the sweeping curves and spirals that carry your eye upward in a zigzag journey (ii) the strong lines of driving rain in different directions, and (iii) the foreshortening device in the clouds and in the folds of the hills. There are even air-screw patterns in the shapes of the mountains. The drama of the electric storm is focused at the golden section of the composition. Above the clouds the sun shines on the mountain peaks.

Analysis of Spiralling Movement in da Vinci's 'Storm over a valley in the foothills of the Alps', c.1506 (2005). Black chalk over giclée. 24 x 18 cm

EXERCISE **Down to earth, after the storm**
Use the composition opposite to create a
view of a lake from a hillside.

1 Print out or photocopy a pale version
of da Vinci's 'storm' or make a rough sketch
of the composition. Change your viewpoint
from that of a bird above the clouds to one
that has swooped down to earth after the
storm has passed. Lower the horizon from
its position off the page, placing it near the
top of the page in line with the furthest
mountain peaks.

2 Convert the hills in the foreground to
undulating river sand, with clumps of
grass here and there to give the feeling of
proximity.

3 Turn the township into pebbles. The base
of the clouds is transformed with a few
horizontal lines to the edge of a lake. Add a
few vertical lines for reflection in the water's
surface. With the addition of trunks and
branches, the clouds are turned into trees.

4 Darken the bases of the mountains in
the mid-distance, so that their appearance
changes to sharp rocks at the water's edge.

*Down-to-Earth After the Storm (2005). Black
chalk over giclée. 24 x 18 cm. Based on da Vinci's
composition of 'Storm over a valley in the foothills
of the Alps', c.1506*

Jagged Outback Outcrop *(1961). Crayon. 28 x 38 cm*

Lofty peaks and lowly rocks

*O painter, when you represent mountains,
see that…the bases are always paler than
the summits…and the loftier they are the
more they should reveal their true shape
and colour.*

Da Vinci made many studies of mountains
for his paintings and also included them in
his landscape drawings, such as the red
chalk drawing of the storm (page 82). His
paintings have mountains in the background
and / or rock formations in the foreground.
For example, mountains appear in *The
Annunciation* and *Mona Lisa. The Virgin of
the Rocks* (page 137) has both rocky caverns
and distant mountains.

Notice the difference between rocks in
the foreground and lofty mountains whose
bases are shrouded in mist. When drawing
rocks, define their ridges with sharp lines.
Use stark contrasts between alternating light
and shade all the way down to their bases.

Leonardo da Vinci, Hurricane over Horsemen and Trees *(c.1518). Pen and ink over black chalk with touches of wash and traces of white, and brush line hatching with white gouache on the horsemen, on grey washed paper. 270 x 410 mm (irregular). The Royal Collection © 2006 Her Majesty Queen Elizabeth II*

This is one of da Vinci's last great artworks, from the period when he drew pure energy from imagination. (He could no longer paint due to paralysis in his right arm, so his creativity was focussed on drawing.) This is a monumental composition, envisaged from a great height. A vast central space renders the horsemen in the corner insignificant and powerless against the hurricane. The tree is flattened. Dynamic curves of wind are drawn in unrelenting swirls of spiralling rhythm. It shows da Vinci's masterful mixed media technique.

Drapery

How one ought not to give drapery a confusion of many folds, but only make them where it is held by the hands or arms, and the rest may be suffered to fall simply where its nature draws it; and do not let the contour of the figure be broken by too many lines or interrupted folds.

Drawing shadows in drapery requires dense filled-in shading. This is the opposite to the general rule of keeping shading lighter than contour lines. Whichever medium you use – charcoal, pencil, chalk or ink – the deep folds of drapery require dense shading in their concavities. Da Vinci fills in solid areas with wash, sometimes reinforcing it with hatching lines. In his brush drawing *Drapery study for the Virgin of the Rocks*, he uses line hatching with white gouache as he did over the horsemen in the storm on page 85.

Everything naturally desires to remain in its own state. Drapery being of uniform density and thickness on the reverse and on the right side, desires to lie flat….

Black Velvet (1961). Charcoal and white chalk on grey paper. 52 x 39 cm

See-Through Garment *(2005). Pastel over giclée. 29.6 x 21 cm. Based on da Vinci's brush drawing of 'Drapery study for the Virgin of the Rocks', c.1496*

There are many drapery drawings supposedly by da Vinci, but not all are convincing. The 'Drapery study for the Virgin of the Rocks' appears to have all the hallmarks of our master. The interpretation here shows the form of the kneeling angel beneath the garment, whose body dictates the shape and fall of the folds. The folds follow rhythmic flowing patterns that enhance the movement of the figure.

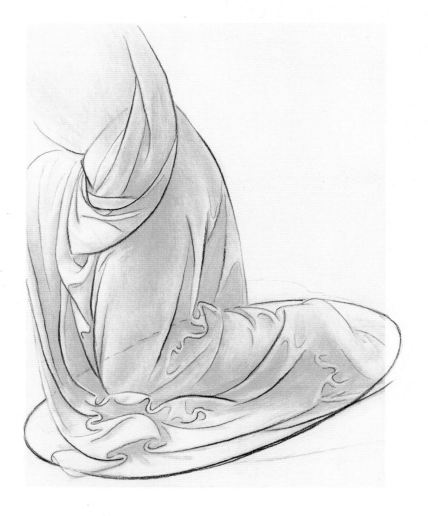

After the Master

Da Vinci's *Drapery study for the Virgin of the Rocks* has traces of black chalk under-drawing, showing that he commenced the artwork by roughing out with free broad lines. He uses the device of placing the figure near the lower border of the page, bringing it closer to the viewer and creating an air of intimacy. This is the opposite to his drawing of the copse of trees on page 80, where he locates the drawing in the top corner of the page to create a feeling of distance.

Drapery Curves *(2005). Black chalk over giclée. 29.6 x 21 cm. Based on da Vinci's drawing of 'Drapery study for the Virgin of the Rocks', c.1496*

Notice how the folds hang in deep scooping asymmetric curves, the tension wavering from side to side. Imagine the angel doused in honey, the thick liquid flowing down the figure and forming a pool on the ground around the angel's knee. This pool of fabric has an overall elliptical shape with the undulating contours of the edge of the drapery resembling the edge of spilt liquid. Broad sweeping arcs of folds are indicated to show how da Vinci would have taken great care to arrange the drapery in a flowing fashion.

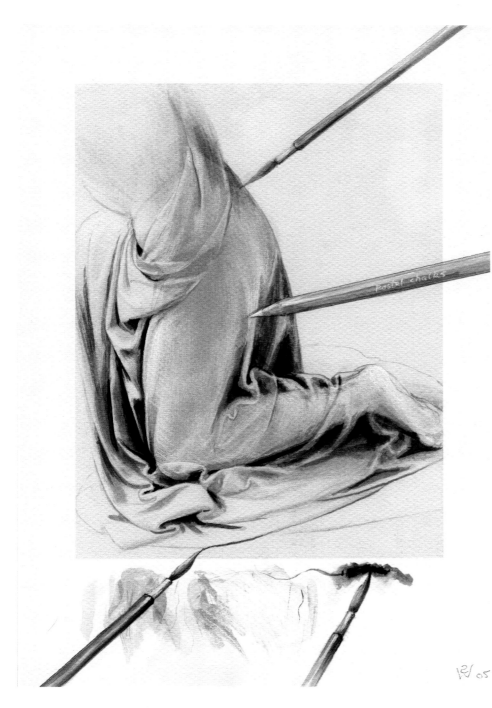

A Brush with an Angel *(2005). Brush and white
pastel over giclée. 29.6 x 21 cm. Based on da
Vinci's brush drawing of 'Drapery study for the
Virgin of the Rocks', c.1496*

You will need:
• a fine longhaired brush
• black paint or ink
• container of water
• sponge or cloth
• several sheets of paper

1 Scan and print out a very pale version
of da Vinci's image, or copy the outlines
onto paper with a pencil.

2 Dilute a small amount of black paint or
ink with water.

3 Test for the right degree of dampness and
depth of colour on a spare sheet of paper,
before applying the brush to the drawing.

4 Practice controlling your hand to draw
fine lines with the brush before committing
to the drawing.

5 Gradually build up the dark areas,
applying layer upon layer of wash.

6 Regularly rinse the brush in the container
of water, and use the sponge or cloth to
remove excess paint from the brush.

7 Once you have finished building up the
tones on the drawing, you are ready to
strengthen the form with hatching lines.

8 Lastly, add fine lines of white highlight
with either a sharpened chalk pastel or
brush with Chinese white or gouache.

EXERCISE 2 **Cardinal garment**
Use watercolour or gouache to colour the drapery. Red is the colour for this part of the drapery in the Louvre version of *The Virgin of the Rocks* (see page 137).

1 Print another pale copy of da Vinci's image or sketch your own.

2 Choose two reds – a deep maroon and mid-cadmium.

3 Apply a pale wash with diluted colour.

4 Gradually build up the colour to maximum intensity in the mid-tone areas areas with layers of wash.

5 Paint the highlights with tones mixed with white; Chinese white can be mixed with red to help grade the paler shades. Brush with fine linear strokes to be consistent with da Vinci's technique.

Cardinal Garment (2005). Watercolour, brush and gouache heightening over giclée. 29.6 x 21 cm. Based on da Vinci's brush drawing of 'Drapery study for the Virgin of the Rocks', c.1496

EXERCISE 3 **After the bath**

Now that you have experienced da Vinci's drapery first hand, it's time to create your own drapery study. Arrange a towel over the back of a chair so that it cascades to the floor and spreads out. Observe patterns and repeated opposites. Notice the logical flow of the folds due to the weight of the towel.

Step-by-step Bath Towel (2005). Four steps in pencil on recycled card. 29.7 x 21 cm

Step 1 – Placement

1 Assess your eye level. It will be above the middle of the page; you are looking down on most of the towel. Gauge height to width.
2 Draw a rectangle, in proportion to the height and width of the towel.
3 Find the centre of the rectangle by drawing vertical and horizontal mid-lines; you may add more guidelines.
4 Establish which part of the towel coincides with the centre of your rectangle.
5 At the upper border of the rectangle, carefully position the top of the pyramidal shape of the towel. Use the vertical centre line to help assess the position of the apex.
6 On the rectangle's lower border, mark the position of the lowest point of the towel and the outer limits of the sides of the towel.

Step 2 – Corners and main folds

1 Draw the oblique lines of the conical folds that fan down and out from the apex.
2 As you draw, observe the angles of the conical shapes, as well as the varying widths of the folds.
3 Lightly mark in the rest of the outline of the towel. Include the angle of the edge of the towel where it hangs off the seat of the chair.

Step 3 – Lines and character

1 Outline the rest of the folds, using the guidelines to assess their positions. Pay particular attention to the corners of the towel that may be visible. (In this drawing, two are on the floor and one is on the chair.)
2 If your towel has a smooth band near the ends, then sketch in the edges of the band where they appear. This helps to give the towel character.
3 Draw in the parallel lines of the towel's smooth hem and selvedge.

Step-by-Step Bath Towel. Steps 1 – 3 (2005). Pencil, on recycled card. 29.7 x 21 cm

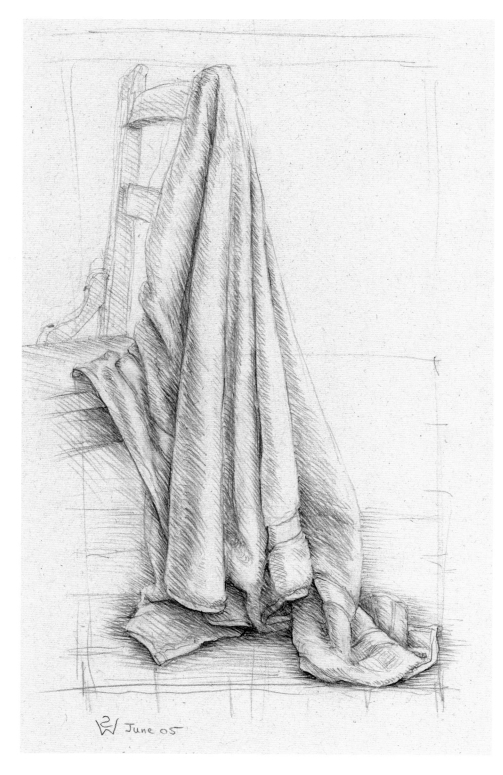

Step 4 – Shading

1 Before you start to shade, observe the direction of the light falling on the towel, and ascertain the areas that are lightest and darkest. In this drawing, the light is to the right of the page and the cast shadows are on the chair side.

2 Shade the towel following the principles described previously, paying attention to the edges of reflected light wherever the towel folds over on the shadow side.

3 Make the shading darkest in the concavities, and bring the shading flush to the edge of reflected light on the contour of the folds.

4 Gradually build up the shading, leaving the darkest areas until last. The edge of the fabric requires a definite sharp line, whereas the edges of the folds should be soft.

5 At the borders where the pile changes to smooth (at the band and edges), apply the method described for drawing animal fur on page 71. This will give the illusion of the fabric's texture.

6 To draw the chair, apply the perspective you have learnt to ensure that the vanishing lines of the top of the chair converge down and away and that those of the seat converge up and away.

Step-by-Step Bath Towel. Step 4 (2005). Pencil, on recycled card. 29.7 x 21 cm

EXERCISE 4 **Tinting a towel**

Now you are ready for tone and colour.

1 Draw a towel, using black and white chalk and one conté colour. Choose a mid-tone that is neither too pale nor too dark.

2 Use a feathering technique, as shown here (and as described in the section on sfumato tomato; pages 64–67). Note that the colour is most intense between the highlights and the deep shadows.

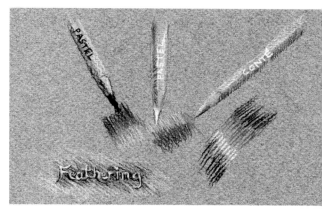

Tinting a Towel in Lilac *(2005). Violet, black and white chalk on grey pastel paper. 29.7 x 21 cm*

Feathering Black and White Pastel and Violet Conté *(2005). Pastel, conté on grey paper. 18.5 x 11.7 cm*

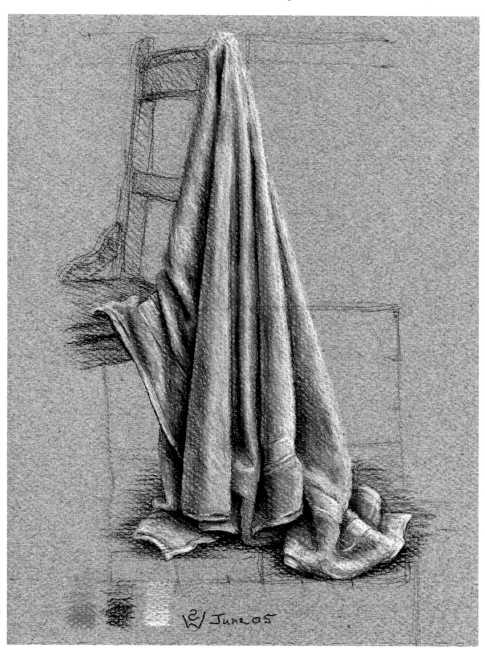

Experiment with tradition

In true da Vinci style, make a scientific study of your subject as well as analysing its shapes and proportions. By investigating and recording your findings in sketches, you will be following in the master's footsteps. The following exercises explain the use of metalpoint with mixed media, combining Renaissance traditions with new experimental techniques.

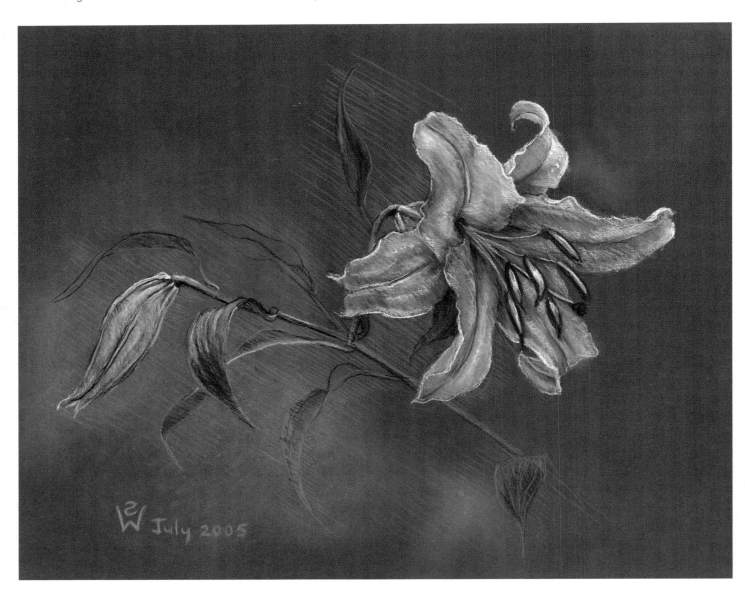

EXERCISE 1 **Gilding the lily**

The materials for this exercise are:
- goldpoint stylus in clutch pencil
- white and black chalk
- dark-grey emery paper

1 Begin by drawing the contours in goldpoint. Then gradually strengthen the mid-tones of the lily using goldpoint hatching.

2 Suggest the shadows with soft black chalk lines. Move the stylus to-and-fro, or scribble in circles over the black pigment until the black and gold merge together in the grit of the emery paper.

3 Add white highlights sparingly. Grade the white with the gold by running the stylus back and forth in a similar way to blend the boundaries in a sfumato effect.

4 You can gild the background in places by applying straight parallel hatching. This softens the edges of the petals while creating atmosphere. A smoky effect in the background is achieved by gently rubbing white chalk using a finger (as seen in the drawing on the opposite page).

Gilding the Lily *(2005). Goldpoint, black chalk and white chalk on emery paper. 23 x 28 cm*

Gilding the Lily – Stages of Bud Opening *(2005). Goldpoint, black chalk and white chalk on emery paper. 28 x 23 cm*

Silver and gold clouds

Here are two exercises in drawing clouds – first in silverpoint on a prepared ground, and then in goldpoint and mixed media on emery paper.

EXERCISE 2 **Silver lining a cloud**

1 Using silverpoint, copy a cloud by da Vinci (or draw your own) onto a blue prepared ground.

2 Silverpoint cannot be erased, so barely touch the ground as you feel your way.

3 Increase the pressure gradually as you draw the contours and shape the form with shadows.

4 Use white heightening for sunlight on billows.

EXERCISE 3 **Golden cloud**

1 Sketch the outline of clouds in goldpoint.

2 Using a smudging technique, touch with charcoal for shadows and white conté for highlights.

3 Scribble with the goldpoint stylus for all your worth until the conté and charcoal are thoroughly fused in a sfumato blend. Repeat the process until you have the desired effect.

Silver Lining (2005). Silverpoint and white gouache on paper prepared with a blue ground. 21 x 21 cm

Gilding da Vinci's Clouds, Golden Rays, Liquid Gold Drawn with Right Hand (2005). Goldpoint, charcoal pencil, white conté on silicon carbide (emery) paper. 28 x 22 cm

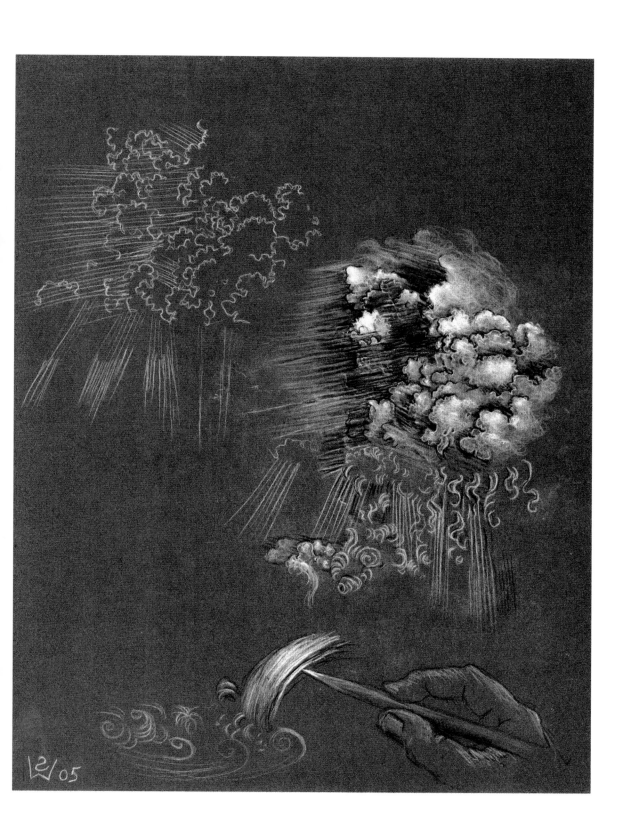

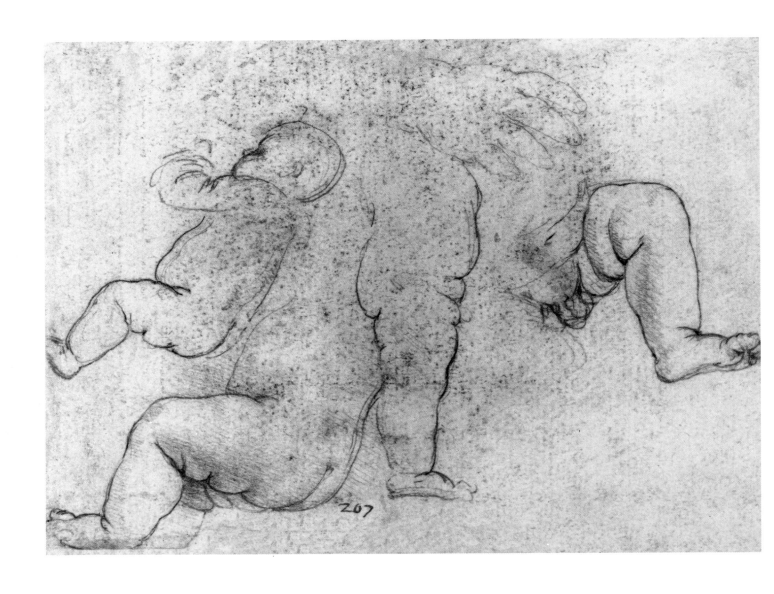

HUMAN NATURE

...the limbs of children are slender at the joints and thick between the joints, as is seen in the joints of the fingers, arms and shoulders, which are slender and have great dimples; and a man on the contrary has all the joints of fingers, arms and legs thick, and where children have hollows men have the joints protruding.

Leonardo da Vinci, Studies of a naked infant (c.1478–80). Red chalk. 138 x 195 mm. The Royal Collection © 2006 Her Majesty Queen Elizabeth II

Human proportions

The length of a man's outspread arms is equal to his height.

From the tip of the longest finger of the hand to the shoulder joint is four hands or, if you will, four faces.

Vitruvian man and woman

Da Vinci took his idea for *Vitruvian Man* from the texts of Vitruvius, a Roman architect in the 1st century BC who wrote about the proportions of the body in relation to the square and the circle. Da Vinci improved on the crude concepts of Vitruvius by placing the navel at the centre of the circle and the root of the penis at the centre of the square, and divided the body parts according to the golden section.

As you see in the illustration, the base of da Vinci's square is a tangent to the circle at the feet. The outstretched feet contact the circle above the square, demonstrating the reduction in a person's height when their legs are in motion.

The head and hand are a useful measure to assess proportions. Observe how many heads fit into the length of a figure – da Vinci's 'Vitruvian Man' is eight heads high. The average height of a person is between seven and eight head-lengths.

Sex Change for Vitruvian Man *(2005). Drafting pen, black ink and gouache. 24.5 x 21 cm. After da Vinci's 'Vitruvian Man'*

Horizontal hatching in the background emphasises the contours of the body and gives depth to the form. It also makes the figure appear lighter in tone than the paper itself. Da Vinci 's 'Vitruvian Man' has both an erect and a flaccid penis.

Early life

Little children should be represented when sitting as twisting themselves about with quick movements, and in shy, timid attitudes when standing up.

In the detail of *Study for Madonna with a cat*, you can see how da Vinci captures these twisting movements. To draw the actions of a child is more difficult than drawing a bird in flight, which da Vinci also did with the greatest of ease!

Leonardo da Vinci, Study for Madonna with a cat; *detail (see page 31)*

Drawing of Baby Paul *(1965). Blue ballpoint pen. 25 x 35 cm*

You should make many studies of a sleeping child before attempting to sketch a wide-awake livewire. Remember that a baby's head is at least as wide as it is high. Compared to an adult, the facial features of a baby are confined to a very small area of the head. Keep the earlobes just above chin level, otherwise you will convert your child to an adult; and keep those ears small – they are the one part of the body that continues to grow after maturity. Drawing a figure on a diagonal creates depth and form.

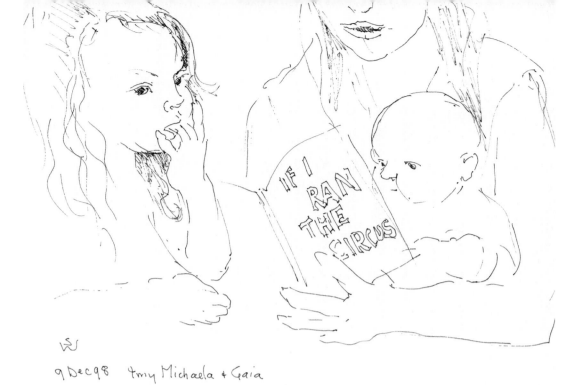

Story-time for Grandchildren *(1998).*
Drafting pen. 19 x 24 cm

The child is wide-eyed, whether they are angry, fearful, curious, listening or day dreaming. To indicate the characteristically intent gaze of a baby, draw the eyes with their whites showing above the iris. Notice the varying hand sizes of the three different ages.

3-year-old Stephen *(1971). Pencil. 38 x 28 cm*

Da Vinci wrote 'Every man at three years old is half the full height he will grow to...'. This three-year old with chubby cheeks grew to be six-foot tall.

Artist – scientist – anatomist

Da Vinci's figure drawing is based on his consummate knowledge of the human body. He made profound discoveries in anatomy through dissections carried out under the most difficult circumstances. The preservatives used today did not exist, and his anatomical work was not always sanctioned by religious authorities.

Fortunately, more than 150 sheets of da Vinci's anatomical drawings have survived. The drawings remain unparalleled to this day. His genius encompassed the three skills of artist, scientist and prosector. No single person since da Vinci has matched this combination. Anatomists have employed illustrators to depict their findings, in stiff wooden drawings, often out of proportion. The so-called Vesalian anatomy drawings were not by Vesalius at all, but by an unknown hand of indifferent skill.

Most of da Vinci's anatomy drawings are in pen and ink with preliminary black chalk underdrawing. For more detailed drawings, he used several strengths of ink, touched with a light brush wash. In his anatomical drawings, we see excellent examples of this and of his use of hatching.

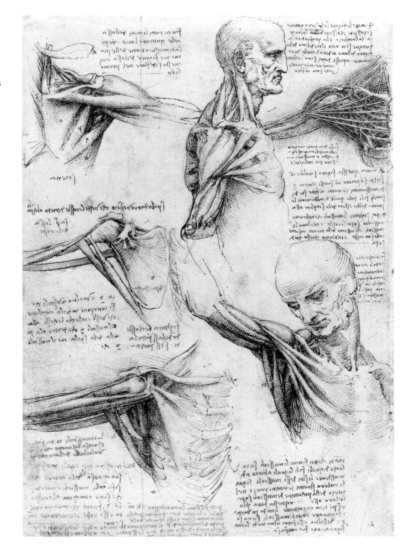

Leonardo da Vinci, Studies of the Anatomy of the Shoulder *(c.1510). Pen and ink with some wash over black chalk. The Royal Collection © 2006 Her Majesty Queen Elizabeth II*

Figuring it out

The shrivelled chest muscles in the studies shown on the preceding page give us an idea of the difficult circumstances under which da Vinci worked, where unpreserved flesh rapidly became dehydrated on exposure to the air. The stench alone must have been daunting. Today we have the opportunity to draw preserved – wet or dry – odourless specimens that have been drained of their blood. Wet specimens are preserved in chemical solutions and dry ones by the new process of plastination.

The significance of da Vinci's anatomical drawings is that he animated the anatomy. Using his imagination, this phenomenal creative skill enabled him to transform a cadaver to an upright position of action. He drew structures as he imagined them in a living person, converting the dead to the quick so that his drawings of muscles, joints and bones are alive and active.

The best way to study the human body is still from da Vinci's anatomical drawings, combined with observation of the living body. This method was good enough for Raphael and countless other artists, so it is good enough for you. If you draw from preserved specimens, remember the muscles are unnaturally extended and distorted.

Dissected Legs (2001) Pastel. 30 x 42 cm

This anatomical drawing is a true 'still-life' of a wet specimen, drained of blood and preserved in formaldehyde. The muscles are extended beyond their natural length. They tend to sag following the dissection process, which removes their supporting sheaths and membranes.

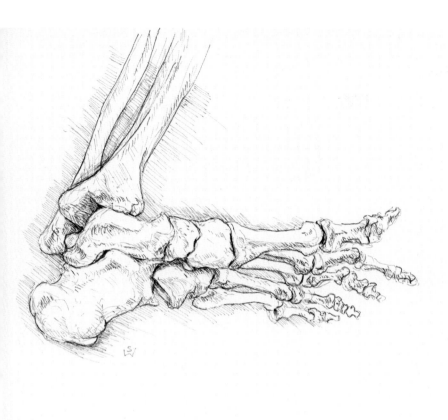

Undersole of Left Foot

2'6 Jan
001

Sole of Left Foot and Ankle *(2001). Brown pen and black pen. 22 x 27 cm*

Thigh-High Goblet; based on da Vinci's 'The skeleton of the trunk and legs', c.1509–10 *(2005). Blue and black conté on buff paper. 27.5 x 21 cm*

2005

The human foot is a masterpiece of engineering and a work of art.

The intricate assemblage of bones in the arches of the dome of the foot supports the whole body. All the toes have three bones and curve down except for the big toe, which has only two and curves up.

EXERCISE 1 **Drawing bones**

The major proportions of the body, such as height and length of legs, are determined by the skeleton. Bones are never straight – notice how your own shinbone arcs forward!

This exercise is orientated for the right-hander. If you do not have access to a skeleton, you can copy da Vinci's drawing. As you work, recall the seven P's: perception, position, placement, perspective, proportion, planes and priority.

1 Perceive the archway made by the pelvis and the bones of the lower limb, which carries the weight of the torso. Notice how the bones curve and twist – none are straight. The thighbones slope inward towards the knee. There is a distinct change in direction below the knee, where the shinbone is more vertical.

2 For position, assess the eye level. It is above the skeleton's knees, as indicated by the horizontal line through the thighbones. This has the effect of making the bones of the lower limb appear longer than in the usual view with our eye level closer to the skull (da Vinci must have mounted or hung his skeleton or sat on a low stool).

3 Divide the page in the centre with vertical and horizontal intersecting lines. The centre of the subject should be placed a little higher than the centre of the page. Mark in the approximate positions of the top of the pelvis and the feet.

4 This is a front-on view, so perspective and vanishing lines are not a concern and there are no problematic distortions to deal with.

5 Work out the proportions and draw horizontal lines to indicate the positions of the ankle and the top of the thigh. In this view, the knees are halfway between the foot and the top of the thighbone.

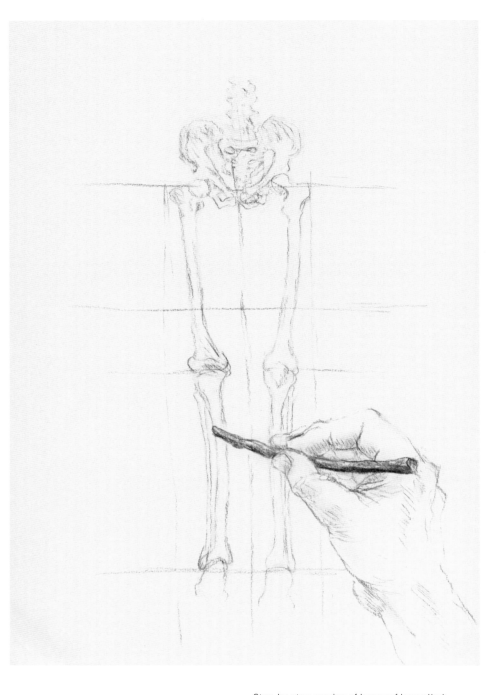

Step-by-step copying of bones of lower limb.
Step 1: Charcoal Roughing Out *(2005). Charcoal and red chalk on buff paper. 29 x 21 cm. Based on a reversal of da Vinci's 'The skeleton of the trunk and legs', c.1509–10*

The thighbone is slightly longer than the shinbone. Mark in the approximate positions of the knees. Compare the various widths of the spaces between the bones and draw the goblet-shaped space between the long bones (see page 105), following the gentle curves of all the bones and leaving the narrow fibula until last.

6 Notice that the tibia and fibula are offset; the outside anklebone is on a lower plane than the bone on the inside of the ankle.

7 Now is the time to determine priority of tone, which gives depth to your drawing. Use pen and water-soluble ink. Start with ink diluted 50% with water in a small bowl. Always keep a sheet of paper beside you for testing the ink before drawing. Sketch in the main contours. Use this same dilute ink for the parallel diagonal hatching lines in the background. Gradually add drops of ink to increase its concentration as you build up your drawing. Use full strength ink in the final stages to bring out the most important areas and prominent contours.

In the style of da Vinci, use a damp brush to emphasize hollows in the pelvis and the shadows by picking up ink already on the page. Keep a sponge handy to remove excess water from your brush. Be cautious. You can ruin your work in this final stage by applying washes that are too dark and that obliterate your lines. The brushwork is a subtle suggestion in the lightest tone, always lighter than the palest pen lines except for drapery.

Step-by-step copying of bones of lower limb.
Step 2: Applying Pen and Ink, then Applying Brush
Tones for Form *(2005). Pen, ink and brush over
charcoal underdrawing on buff paper. 29 x 21 cm.*

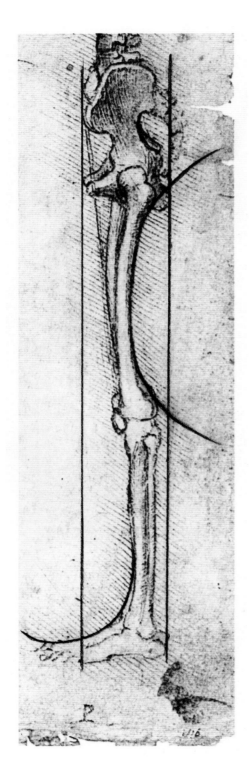

Homo erectus

And let the hollow of the throat always be exactly over the middle of the joint of the foot, which is resting on the ground.

Compare da Vinci's drawing (left) of the bones of the lower limb in side view with his silverpoint of the limb muscles from the same view (opposite). Notice the beautiful curve of the thighbone and the arc of the shinbone. Also observe the alignment of the pubic bone and the front of the hipbone with the ball of the foot.

Moving muscles

Male nude from back and side is a masterful mixed-media drawing, and shows da Vinci's understanding of how the muscles are arranged beneath the skin. In the arm, he exaggerates their ropey form. In the thigh he shows the tension in the massive quadriceps, hamstring and buttock muscles that help to keep the body erect and move the legs.

The drawing of the skeleton of the lower limb at left shows da Vinci's method for understanding the action of a muscle by depicting it as a stringline between its attachments to the bones. The particular muscle (sartorius) indicated here by a stringline crosses both hip and knee joint, resulting in flexion at each joint.

Arcing Bones (2005). Pastel chalk on giclée. 24 x 8 cm. Based on da Vinci's 'The Skeleton of the trunk and legs', c.1509–10

Leonardo da Vinci, Male nude from back and side, c.1490). Metalpoint with white highlighting on blue prepared paper. 177 x 140 mm. The Royal Collection © 2006 Her Majesty Queen Elizabeth II

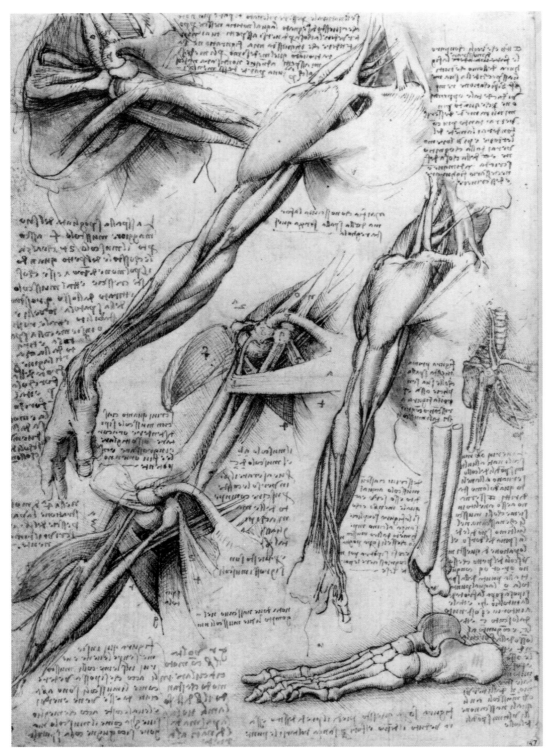

Leonardo da Vinci, The anatomy of the right upper limb, shoulder, and left foot (exploded view), *(c.1508–11). Black chalk underdrawing, pen and ink, wash. 289 x 210 mm. The Royal Collection © 2006 Her Majesty Queen Elizabeth II*

The drawing of the 'exploded' ankle joint, with the vertical displacement of the leg bones indicated by lines, anticipates the diagrams of assembly kits. Da Vinci was probably the first to use this concept in drawing.

...and the limbs, and especially the arms, should be easy, that is, that no limb should be in a straight line with the part that adjoins it.

Da Vinci recommended drawing at least eight different views of limbs. Among his many drawings of the upper limb is a set of two pages where he drew eight views of the limb in successive rotation, four on each page.

1 Study bones of the upper limb by copying da Vinci's drawings, using the same method as for the lower limb skeleton exercise. Notice that one bone of the forearm rotates around the fixed bone that makes the point of the elbow. Thus the two bones of the forearm can be either crossed (upper left) or parallel (middle).

2 Lightly sketch the bones of the arm in chalk or pencil; then draw the muscles using da Vinci's drawing on the opposite page as a guide. The fleshy bellies of many muscles that move the fingers are located in the forearm, their long tendons passing to the hand via the front and back of the wrist.

3 Flesh out the muscles using pen and wash. Muscles require curving contours that roll over each other like a hilly landscape. Note that da Vinci reserves the cross hatching for the deepest hollows, and uses single hatching to shape the undulating muscles.

4 Observe the landmark change in the contour of the forearm where the muscles to the thumb emerge.

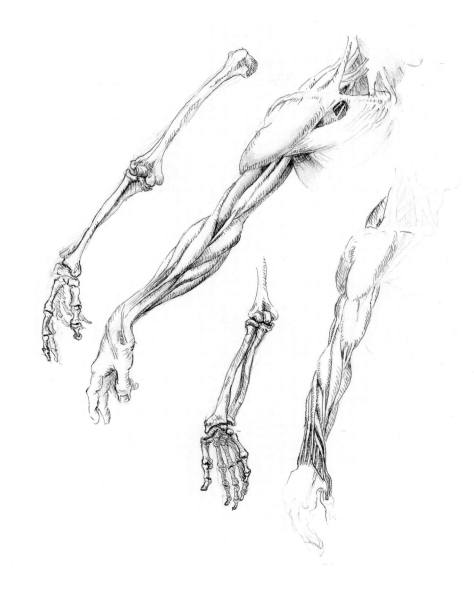

Right Upper Limb: Muscles and Bones, Rotation of Forearm *(2005). Calligraphy pen, ink and brush, pencil underdrawing. 29 x 21 cm*

Da Vinci discovered that a muscle of the arm (biceps) is responsible for both flexion of the forearm at the elbow and uncrossing the forearm bones to turn the palm upwards.

Art on a sleeve

Da Vinci drew many studies of arms in sleeves for his paintings. In his drawing here, da Vinci cleverly reserves the white chalk for the sleeve only; this contrasts with the organic arm suggested in red.

To draw bunched-up sleeves, it is helpful to see boomerang shapes in the cloth. Draw the basic forms of hollows and accentuate the edges as in the towel exercise (page 91).

What's up Sir Leigh Teabing's Sleeve? (2005). Red, black and white pastel chalks on red-ochre toned Ingres paper. 32.5 x 25.5 cm

Many tones and textures can be achieved by the technique of varying the density of the white chalk and incorporating the bare paper as part of the tonal variation.

Leonardo da Vinci, Study of tunic of Christ as Salvator Mundi / Studies of drapery (1510–15). Red chalk with touches of black chalk and white heightening on orange-red prepared paper. Dimensions. The Royal Collection © 2006 Her Majesty Queen Elizabeth II

The two forearm bones are in the parallel position, with the palm facing upwards (supination).

Handy hints

Da Vinci described the two extreme turning positions of the hand as facing the ground and facing the sky (referred to anatomically as pronation and supination, respectively). An understanding of the bone structure of the forearm and hand is necessary to draw its gestures in the same way that knowledge of the skull helps with drawing the head. Da Vinci understood that the hand is capable of an infinite number of movements and expressions.

Digital Comes in Handy (2005). Pen, conté, pastel, white correction fluid on giclée. 29 x 20.5 cm

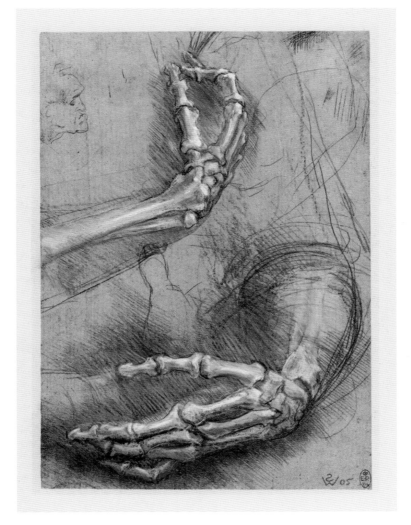

Hands complete the portrait

Da Vinci's portrait paintings all have hands to complete the expression and mood of the character. If hands are missing from a da Vinci painting, it is a sure sign that the painting has been 'amputated'.

Da Vinci's *Studies of a woman's hands* (page 114) is considered by some to be a study of hands for his *Yarnwinder Madonna* portrait, and by others to be a study for the portrait of *Ginevra de'Benci* (see page 115). Da Vinci understood the psychology of gestures, exploiting them to the full in his paintings, from the composure of Mona Lisa to the dramatic gestures of the disciples in *The Last Supper*. The gesture of the pointing finger recurs throughout da Vinci's art and is seen in two paintings in the Louvre. The angel in *The Virgin of the Rocks* points toward the Christ child, and the arm in *John the Baptist* sweeps in an arc that ends in the tip of the pointing finger. The space enclosed in the hollow of John's curled fingers resembles the head and neck of a goose. In *The Last Supper*, the figure on Christ's left points directly upward with the same gesture.

Leonardo da Vinci, Studies of a woman's hands
(c.1475). Metalpoint with white heightening over black
chalk on pale buff prepared paper. 214 x 150 mm.
The Royal Collection © 2006 Her Majesty Queen
Elizabeth II

There is a marked discrepancy in the size of the
hands – da Vinci has drawn the upper hand much
smaller than the lower one in the foreground. This
creates depth. Da Vinci leaves a thumb behind where
he changed his mind about the position of the hand.

Uncle Ted Telling a Joke *(1975).*
Drafting pen. 24.5 x 26 cm

A hand is the size of a face, but the fact that the
hand is invariably to the fore means that it must
be drawn proportionally larger to be in perspective

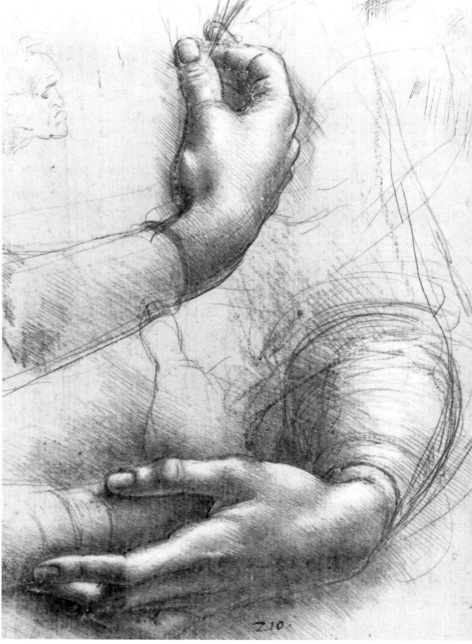

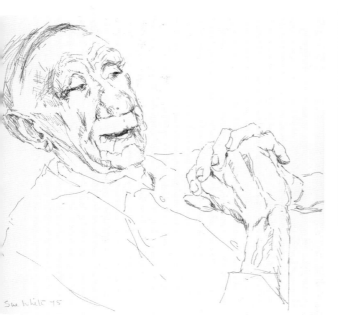

EXERCISE **1 Perform microsurgery**

Attach the hands in da Vinci's drawing on page 114 to the amputee *Ginevra de'Benci*. Da Vinci would have painted her with hands. Study of the proportions and the verso (rear) of the painting in Washington indicate that about one-quarter has been cut from the bottom.

1 Download or print out a picture of *Ginevra de'Benci*, allowing ample space for the hands.

2 To determine the position of Ginevra's hands, use the composition of *Mona Lisa* as a guide. Pencil in the hands at the golden section so that the far eye is above the centre of the hands.

3 Modify da Vinci's drawing so that *Ginevra de'Benci* fumbles with a ring (thought to have been threaded on the ribbon hanging around her neck).

4 Complete the drawing with pastel or conté. Invent your own style of sleeves to complete the surgery.

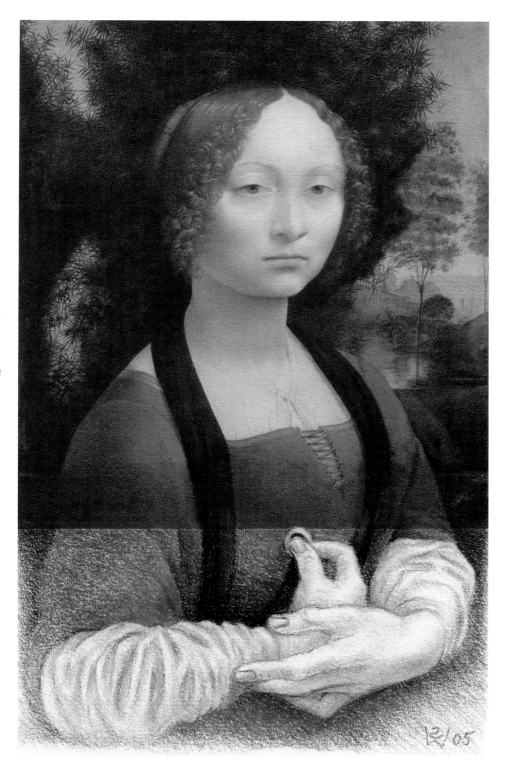

Surgery Reattaching Ginevra de'Benci's Arms and Hands *(2005). Graphite pencil underdrawing, coloured pencil and conté, 29 x 21 cm*

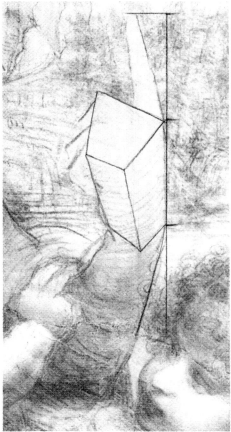

EXERCISE 2 **Complete granny's hand**
Finish drawing the hand of St Anne (the mother of the Virgin Mary) for da Vinci, using the sfumato technique. You will need black and white chalk or charcoal.

1 Print out the hand from the cartoon onto light brown pastel paper.

2 Before starting, observe three basic planes:
(i) on the back of the hand, expanding from the wrist to the knuckles
(ii) on top of the three fingers (that curl at different angles), widening towards the pointing finger
(iii) at the side of the hand.

Important landmarks are the dome made by wrist bones on the back of the hand, and the small projection of the forearm bone (ulna) on the back of the wrist on the side of the little finger. On the underside of the hand is the rounded muscle of the ball of the little finger. The pointing finger is the same length as the back of the hand.

3 Use your new skills to blend black and white to shape the hand with soft grey shading. Use white to emphasize the knuckles, back of the pointing finger, and tendons on the back of the hand. The shading and highlighting should correspond to the direction of the light from top right.

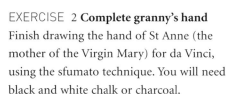

Leonardo da Vinci, Cartoon for the Virgin, Child, St Anne and St John; *detail (see page 62)*

Planes of St Anne's Hand *(2005). Chalk over giclée. 19.5 x 9 cm*

Granny's Hand Completed *(2005). Black and white charcoal over giclée on brown paper. 29 x 21 cm*

Seeing a head

Here we consider the position of the skull in relation to the face and head. The skull lies just beneath the skin of the top of the head, the forehead and the cheekbones. The skull determines the proportions and shape of the head.

An understanding of the structure of the skull is essential for portrait drawing. Familiarise yourself with the skull's form by feeling your own head and observing others.

Most of the skull bones lie just beneath the skin; therefore their structure is visible and palpable. The only parts of the face with shapes that are independent of the skull are the nose below the bridge, the lips, eyes, ears and cheeks. A child's chubby cheeks contain pads of fat that conceal the cheekbones, whereas a thin face, such as da Vinci's *St Jerome*, has hollow bony cheeks.

Mona's Bones *(2002). Pencil, brush, gouache over giclée. 24 x 19 cm*

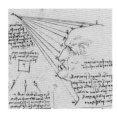

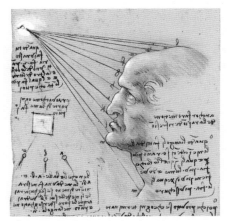

Illuminated Profile *(2005). Pastel, conté, white correction fluid over giclée. 30 x 21 cm*

These images from da Vinci's 'Study of the fall of light on a face' (c.1487–90) demonstrate his analysis of the effect of light falling on the head. Pastel highlights are added, showing how a three-dimensional illusion can be developed through understanding the effects of light and shade.

Angry Anghiari *(2005). Pastel and conté over giclée. 30 x 21 cm*

This drawing is based on da Vinci's 'Study for the head of a warrior in the Battle of Anghiari' (1504-05). It shows the extent to which the head is lengthened by opening the jaw. The one main moveable joint in the head is between the jaw and the temple bone.

A common mistake is to make the head the shape of an egg, or an oval on a cylinder. The closest shape to an egg is the outline of the skull viewed directly from above, with the wider part at the back.

Raising the profile and facing proportion

Profiles are simple, and direct. Da Vinci realised the potential in profiles as a powerful means of delineating characters. His many drawings of grotesque caricatures are in profile (see page 125).

Drawing profiles is an excellent way to begin portraiture. With only one side of the face to draw, perspective is not an issue. This allows you to concentrate on proportion and expression. The power of expression in one eye and one side of the face should not be underestimated.

The space between the parting of the lips and the base of the nose is one-seventh of the face.

A common error is to squash the brain by slicing off the back and top of the head. Include the space that rises to the crown. In profile, notice how the head is deeper than it is wide. In the drawing bottom left, da Vinci's lines are extended in red to show that the head's highest point is at the golden section, closer to the back in line with the ear hole. Do not place the ear too far forward. To avoid making the common error of placing the eye on the side of the nose, observe that the inner corner of the eye is set back from the nose bridge by the width of an eye, demonstrated here by da Vinci's small rectangles. Da Vinci aligns the base of the skull, the ear lobe and nostril. You can continue decoding his lines...

Michaela (1977). Charcoal. 35 x 27 cm

The far arm is small and faintly drawn to create depth. Even when drawing jet-black hair, the bare surface of the paper should be left in places to obtain the full tonal range. Avoid filling in as this flattens the form.

Profile in Proportion (2005). Drafting and red felt-tip pen over giclée. 11 x 11 cm. From da Vinci's 'Studies of proportions', c.1490-94, and his studies for the 'Battle of Anghiari', c.1503-04

In da Vinci's drawings to demonstrate proportions, he uses the square to encompass facial features. Be aware, though, that da Vinci's proportional guidelines are appropriate only to each particular face, and so they will vary from individual to individual.

Drawing on the senses

For positioning eyes, noses and mouths, first draw the shapes that surround them. Observe the varying planes of the surrounding forms. Indicate their shapes with hatching. Features drawn isolated from their environment will look flat – your drawing will be as shapeless as a face sketched on an egg!

A common mistake in drawing eyes is to place the lids on the same vertical plane, whereas the plane is actually inclined obliquely backwards with the upper lid overhanging the lower. The eye sits in its own cave under the overhanging brow. Similarly with the mouth, the top lip usually over-hangs the lower, as seen in da Vinci's drawings of females and young men. When drawing old men with missing top teeth, da Vinci gives them a characteristic protruding bottom lip and jutting jaw.

Ears do not contribute to expression, so make them inconspicious except when drawing a face in profile. In this view the ear is to the fore and drawing it in detail will add depth. See da Vinci's use of this effect on pages 119 and 125.

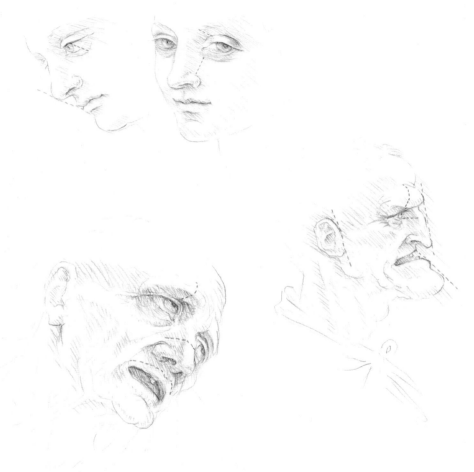

Eyes, Mouths, Noses, Ears: Drawing the Four Senses (2005). Graphite and coloured pencil. 24 x 21 cm

Coloured pencil lines indicate the planes.

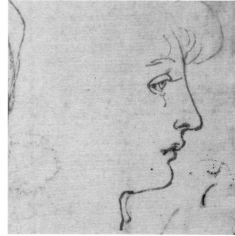

Leonardo da Vinci, Studies for a Madonna with a cat; detail (see page 31)

Here da Vinci skilfully captures the essence of a face in a few lines by applying his understanding of planes and proportions.

EXERCISE 1 **Face-on portrait**

Here you learn to draw a head front-on, following a da Vinci drawing with his proportional guidelines. A 2B pencil is recommended.

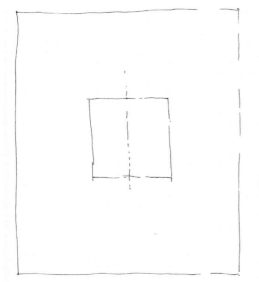
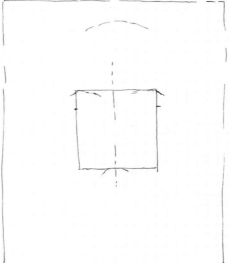
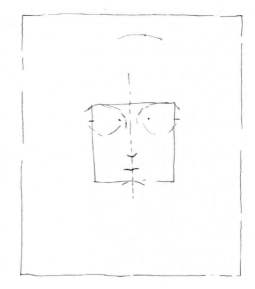

Step 1

i. Orientate your page to portrait format.
ii. Draw a vertical line in the centre. Draw a square around the line so that the square is slightly above the centre of the page. The main features of the face are to fit within this square.

Step 2

i. Sketch in the curves of the eyebrows with their crests touching the top of the square. Notice that the brow ridge has the shape of a flying bird with outstretched wings.
ii. Draw the upper curve of the chin to touch the bottom of the square, as shown. Mark in the crown of the head a square length above the eyebrows.
iii. Position the outer corner of each eye on the sides of the square, as shown.

Step 3

i. Mark the inner corner of each eye with a dot, slightly lower than the outer corners (the age-old rule is that the distance between the eyes is the width of an eye).
ii. Sketch the tip of the nose in the mid-line, one-third of the distance up from the base of the square.
iii. Suggest the curve of the lower bony ridge of the eye socket, about halfway between the tip of the nose and the top of the square.
iv. Indicate the bridge of the nose with two short vertical lines.
v. Mark where the lips meet; this is about halfway between the tip of the nose and the crest of the chin.

Step-by-Step Square-on Portrait *(2005). Six steps. Drafting pen and black and brown ink. 14 x 12 cm. From da Vinci's 'Proportion studies of head and eye', c.1489–90*

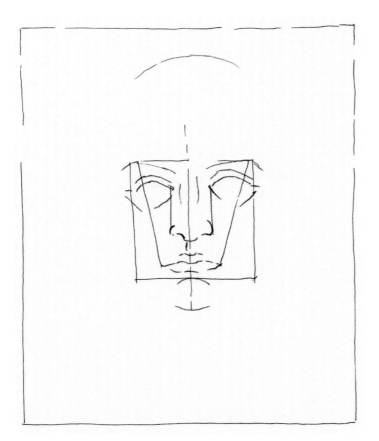

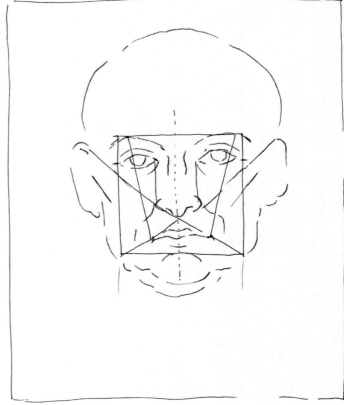

Step 4

i. Mark the corners of the mouth about one-quarter of the way in from the side of the square.

ii. Drop an oblique line from the eyebrow crest to the corner of the mouth.

iii. Draw the curve of the line between the lips that mimics the brow shape of a flying bird; the uppermost and lowermost boundaries of the lips should be suggested only in their middle section.

iv. From the inner corners of the eye, drop two parallel vertical lines to the outer edge of the wings of the nose (this is the widest part of the nose and is equal to the width of an eye).

v. Sketch in the curved nose wings (higher than the tip of the nose) leaving gaps where the curves change direction.

vi. Mark in the lower edge of the chin below the square.

Step 5

i. Starting at the lower corners of the square, extend two oblique lines upwards through the corners of the mouth, crossing at the tip of the nose and passing through the outer margin of the lower ridge of the opposite eye socket. The highest point of the oblique line is where the top of the ear is attached. You may have to adjust your drawing at this stage to accommodate the guidelines.

ii. Draw the ears, noting that they are the same length as the nose and keeping them feint so that they recede. Note that the ear lobe is to the fore.

iii. Mark the lower edge of the cheekbone with a line as shown,

iv. Sketch in the two curves of the upper eyelid (the top arc curves more than the eyelash arc) so that the widest part of the lid lies above the iris. Draw the lower eyelid (lightly, leaving a gap in the middle).

v. Outline the semicircle of the iris so that it almost touches the lower eyelid and the oblique guideline, as shown.

vi. Make any necessary adjustments, e.g., at the edges of the eye socket.

vii. Draw the dogleg curve of the cheek crease either side of the wings of the nostril.

viii. Suggest the curved outline of the neck in line with the vertical sides of the square.

ix. Draw the contour of the temples, leaving gaps to create the illusion of roundness. Make sure there is ample space between the sides of the square and the outer contour of the head. This space is about the width of an eye; there are effectively five eye-widths across the head at the eyebrow level.

x. Draw the outer contour of each cheek outside the square to meet the lower corners of the square.

xi. Connect the lower cheek to the chin with a curve on each side and draw in a jowl line (dewlap) below the curve of the chin with a broader arc.

Step 6

The only asymmetry used by da Vinci in this drawing is the light coming from above left (right side of the drawing), casting shadows on the other side.

i. Refine your drawing, starting with the eye sockets. Lightly suggest the large space they occupy between the brow and the cheekbone ridge. The pupils of the eyes are at the golden section of this space. The amount of iris and pupil showing depends on the person's expression. Although alert and concentrating, these eyes are not uptight and intense. To achieve this expression, position the pupil so that it is ever so slightly concealed by the upper eyelid.

ii. Partially fill in the pupil (remember that complete filling in is out).

iii. Darken and thicken the eyelash line of the upper lid; the intensity of the line should ease off towards the inside corner of the eye; continue the line beyond the outer corner. Shade the top of the eyeball where the overhanging eyelid and lashes cast a shadow (this is one of the darkest regions of a face).

iv. By hatching lightly over the entire area of the eye socket, da Vinci seats the eye back in its socket beneath the protruding brow. Shade this area lightly with straight parallel lines. Then strengthen the shading in the hollow just below the brow and shape the region of the lower eye socket area with varied directional hatching.

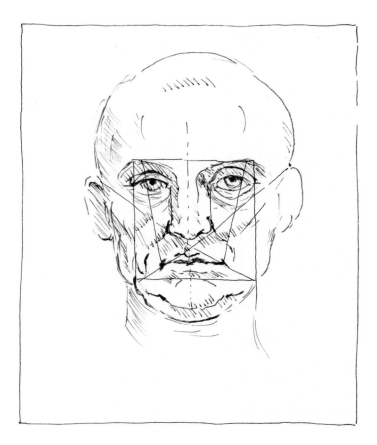

v. Carry the contour of the wing of the nostril under and into the aperture, as in the drawing, to make the tip of the nose protrude.

vi. Shade along one side of the nose and add a spot of shading beneath the tip and nostrils, leaving a line of reflected light. Shade the groove at the crease beside the nostril.

vii. Other refinements include shading under the chin, under the top lip, the hollows of cheeks, the right ear and the temple, as da Vinci has done. Mould the undulations of the forehead and brow with a hint of hatching. A line of reflected light will add form to the chin. Suggest the philtrum with a few feint shading lines (outlining it will flatten its shape). The line between the lips and the creases at the corner of the mouth can be shaped and strengthened. Shade only the top lip; the light falls on the bottom lip.

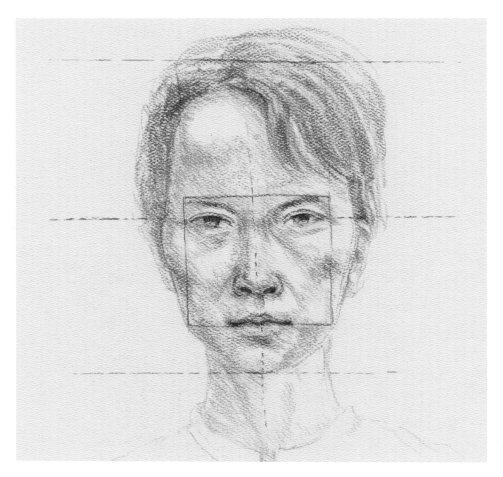

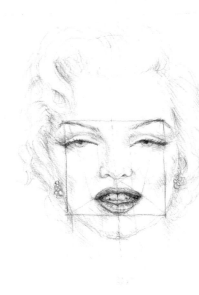

Do You Look Like This? *(2005). Pencil. 18 x 14 cm*

Here's Looking at You *(2005). Pastel, conté on red pastel paper. 30 x 21 cm*

Five characters in a comic scene *(c.1490). Pen and ink. 261 x 206 mm. The Royal Collection © 2006 Her Majesty Queen Elizabeth II*

EXERCISE 2 **Face-to-face self portrait**

To draw a front-on self-portrait, follow the procedure of exercise 1. You are unlikely to have the same facial proportions, so adjust the position of your features in relation to the square. Begin again if your page becomes unmanageable – it is better to make many drawings than to produce a perfect disaster. By keeping your lines light and free, you allow yourself room to manoeuvre, change your mind and adjust relationships.

1 Draw a free-hand vertical line in the centre of the portrait-format page. Keep the line light and approximate.

2 Draw a square for the area of facial features – the square should be bisected by the vertical line, but slightly closer to the top of the page (do not spend all day trying to draw a perfect square).

3 If you have similar proportions to the person in the conté drawing *Here's Looking at You*, draw the lip line at the base of the square. If you have a short face like the person in the pencil drawing, place the top of the chin at the base of the square.

4 Mark the position of the crown of your head in relation to the square.

5 Allow plenty of space to shape the mouth – it occupies a larger area than is apparent.

6 The distance between the top of the nostril wing and the inner corner of the eye is crucial for determining a likeness. This distance is comparatively short in *Do You Look Like This?* and longer in the conté drawing and in the portrait of *Mona Lisa*.

7 What you leave out is as important as what you include. Drawing ears in detail will bring them to the foreground, and detract from important features. Allow them to recede in the distance where they belong.

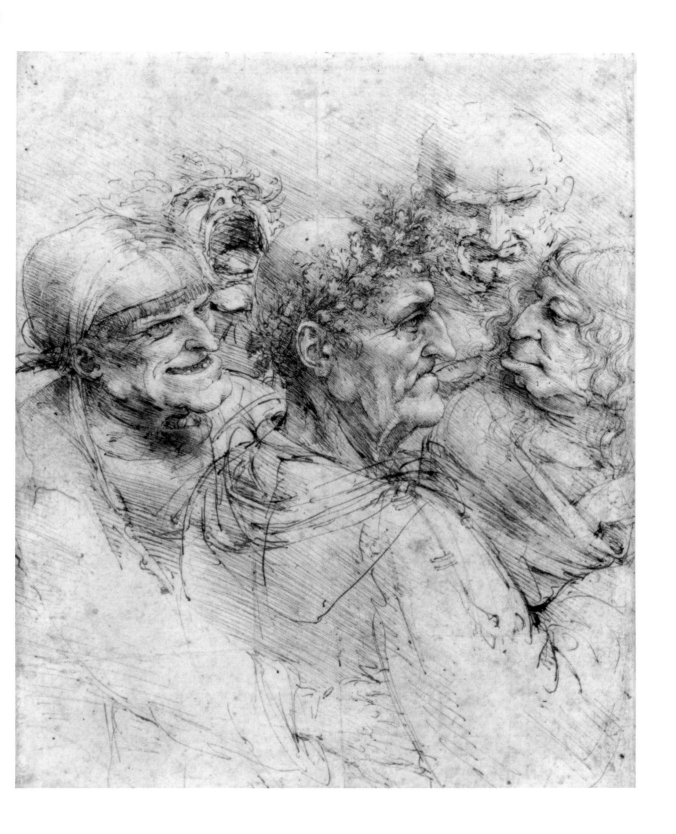

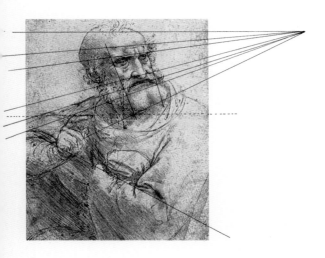

Peter in Perspective *(2005). Pen, ink, giclée. 21 x 30 cm.*

Based on da Vinci's 'First idea for the figure of St Peter' (c.1490), this illustration demonstrates how vanishing lines can be used to draw a face in three-quarter view in correct perspective.

EXERCISE 3 **Facing perspective**

The same pose may display infinite variety because of the infinite places from where it can be seen.

This is an exercise in determining vanishing lines on da Vinci's drawing of Peter, whose head is turned in three-quarter view. Once the head is turned slightly, foreshortening and perspective are involved. If perspective is not applied to drawing a head in three-quarter view, the face will become highly distorted.

In three-quarter view, the far side of the face is smaller, as are the respective distances between eyebrow and eye, eye and mouth, and mouth and chin. Some artists mistakenly make the left and right features the same size. A series of vanishing lines drawn through (i) the eyebrow ridges, (ii) the corners of the eyes, (iii) the corners of the mouth and (iv) the slope of the chin are essential to draw the face in perspective. A helpful way to visualise these perspective lines on a face is to imagine that the face is drawn on an opened hand-fan, with the ribs representing the vanishing lines and the pivot the vanishing point.

1 Find your eye level in relation to the head (note that the line through the subject's eyes is not to be confused with your eye level). In da Vinci's drawing of Peter, the face is below eye level so the horizon is near the crown of the head and the vanishing lines converge upward to the vanishing point off the page.
2 Notice that da Vinci has drawn the head turned at a different direction to the body, so that Peter's left shoulder and right eye are in the foreground and his hand points in the

direction of his intense gaze.
3 Draw vanishing lines through the crest of each brow ridge, the edge of each nostril, the corners of the mouth and the lower edge of the beard so that all these lines converge at the same vanishing point. You can add more; for example, through the upper and lower eyelids.
4 This will give you a framework for drawing portraits in three-quarter view. You will find that you need to keep adjusting the positions of the features of the face. Vertical (plumb) and horizontal lines are useful for gauging positioning landmarks in relation to one another. First draw the shapes around the features, such as the eye-sockets, brow ridges and cheeks. Leave shaping the details of the eyes, nose and mouth until last.

Muscles of Disgust *(2005). Black chalk and coloured conté on buff paper. 26 x 19 cm. After da Vinci's 'Study of a man's head in profile to right', c.1503-04*

Expressive heads

Da Vinci's understanding of the facial muscles enabled him to create convincing expressions from a serene smile, to disgust, contempt and anger. The intricate flat facial muscles pull between bone and skin. They are responsible for the infinite variety in facial expression. The eye and mouth are surrounded by broad bands of circular muscles; others pull parts of the face in many directions, such as elevating or depressing the corners of the mouth, the nostrils and forehead. See the muscles expressing disgust opposite.

Practise drawing caricatures by exaggerating features. Da Vinci drew many grotesque heads, such as the characters on page 125. The head with the open mouth is thrown back, foreshortening the bridge of the nose and the forehead so that they are completely obscured.

Head-turner

The graceful turn of the head is a distinctive feature of da Vinci. This movement is the hidden beauty that we respond to in his art. Already as a student, da Vinci painted an angel with a turn of the head that earned the praise of his master Verrocchio.

The important muscle that turns the head is prominent at the side of the neck; it passes obliquely from behind the ear and forks to attach to the breastbone and collarbone (see the heads and necks in da Vinci's anatomical studies on page 103). When the muscle shortens on one side, it turns the head to the other.

When composing portraits, follow our master and turn the head. Allow the eyes to lead the movement. This natural human action is seen repeatedly in da Vinci's art.

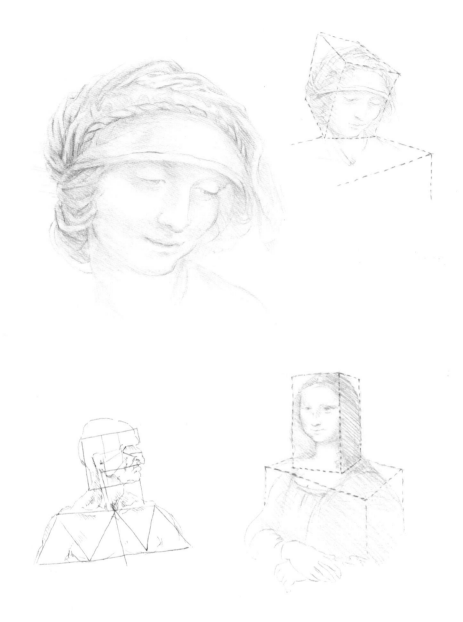

Heads Turned on the Block: Heads of St Anne and other da Vinci Characters (2005). Pencil, pen and conté. 29 x 21 cm

The heads and torsos of St Anne and Mona Lisa are placed in blocks to demonstrate the movement. Notice the prominent ridge of the man's head-turning muscle as he looks to the left. St Anne's head is both turned and tilted; her right eye and left shoulder are in the foreground. Da Vinci uses the same tilt and turn of the head for the Virgin in his 'Adoration of the Magi' (page 130). Critics often disparage the drawing of St Anne and da Vinci's Madonnas, misinterpreting the sublime expression of a doting mother that da Vinci observed and understood.

The quintessential portrait

How to give Mona a pricking, spulverising and sun-baking! *Mona Lisa* probably commenced life as a series of pinpricks from a cartoon. (A cartoon is a drawing the size of the actual painting.) The cartoon was pinpricked to transfer the outlines to the surface of fresco or wood panel.

Mona Gets Her Pillars Back – Pricked, Spulverised, Silverpointed, and Sunbaked *(2005). Silverpoint on gesso board. 35 x 25 cm*

Notice how the re-instatement of the loggia pillars improves the composition. Exposure of a silverpoint drawing to the sun speeds the patination process, changing the silver from grey to brown.

Black pigment was stamped through the pinholes using a pouncing bag, leaving black dots on the plaster or gesso for the artist to follow. This technique was called 'spolvero'. Da Vinci preferred dry surfaces called 'secco'; Mona is on a prepared poplar panel.

Da Vinci places Mona on top of the world in a purely imaginative environment. This reflects his passion with heights and flight, and we experience the associated feeling of elevation. Unfortunately the painting was trimmed at the sides, removing the pillars of the loggia (parapet) that framed Mona. These added to the sense of intimacy and enhanced the distance behind her. Da Vinci used this framing device in other compositions.

To add to the speculation about the identity of *La Gioconda* (Mona Lisa), note her puffy fingers – these could suggest fluid retention, a characteristic of pregnancy. Did da Vinci paint an imaginary portrait of his mother? This would explain why he never parted with it, taking the painting with him when he went to France. She is unadorned with jewellery, possibly indicating the peasant status of his mother. If the painting were a commission, why did he keep it? Or is Mona really a man? She has the broad shoulders of a masculine skeleton and the facial proportions of da Vinci himself.

Characteristically, da Vinci turns Mona's head in relation to her body, so that her head and hands twist in the same direction towards the viewer. Mona's eyes are on the horizon line and therefore correspond to the eye level of the viewer. Da Vinci has used this clever device, placing the horizon line through the middle of the pupils, so that Mona's gaze follows the viewer from every angle and position. Her eyes are at a golden section above the ledge of the parapet, and this ledge is at a golden section of the whole painting. The shift in the background landscape between two levels on either side of her face tricks our minds into sensing movement – the landscape rises up and up in a similar bird's eye view perspective as in *Storm over a valley in the foothills of the Alps* (page 82). The depth achieved by aerial perspective is developed to the full in the painting of *Mona Lisa*.

Da Vinci's thorough understanding of the muscles of facial expression enabled him to create this convincing smile. Observe how Mona's muscles elevate the surface of her face, making the eyes smile where the lower lid is raised to partially cover the iris. The sfumato technique of blurred outlines suggests movement, and so captures several stages of the fleeting smile in one image. This movement mesmerizes the world.

EXERCISE **Use Mona to draw a star**

1 Download Mona and print out a pale version, or make a light photocopy, or copy it yourself. (You could also try the technique of pricking the image onto a gesso board and doing a silverpoint drawing.) Now that you have mastered proportion, perspective and shading, you can use photographic images intelligently, recognising and fixing optical distortions, knowing what to select and avoiding the copying of unnecessary shadows and meaningless shapes.

2 If it helps, draw in the horizon line (eye level). Your whole portrait will revolve around the focal point of the eyes situated on this line; subsequent drawing of shapes and proportions must be adjusted to relate to the position of the eyes.

3 Choose a character to superimpose on Mona.

4 Study many different viewpoints of your star so you gain a feel for the structure of the head, face and upper body.

5 Superimpose your star on Mona with pencil. Converting Mona to John Lennon is easy as he has similar facial proportions, especially in the nose and mouth. Lengthen and strengthen the chin (to make it more masculine) and raise the eyebrows, making them thick and bushy. The proportions of the face need lengthening and narrowing.

6 Invent your own imaginary, distant background.

This exercise makes you realise how unlike a photograph is the work of da Vinci. He subordinates the shadows, using them only to create form, adjusting the tones of light and dark in an imaginative way to accentuate expression and movement.

Star on Moon: John Giocondo *(2005). Graphite pencil, blue pencil and damp brush over giclée on blue paper. 30 x 21 cm*

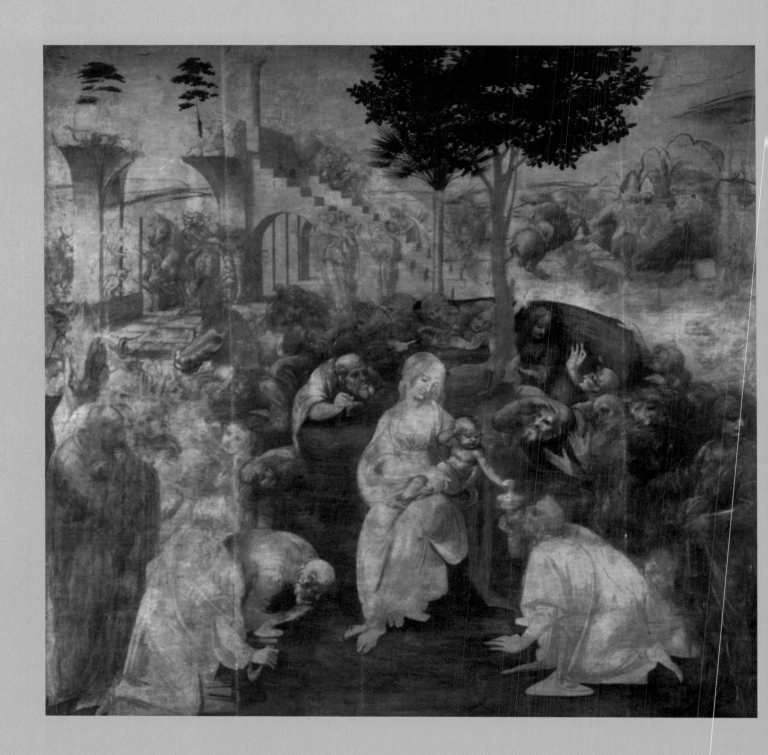

COMPOSING AND DRAWING CONCLUSIONS

Drawing is the foundation of da Vinci's compositions. He made numerous sketches of the initial spark of an idea, usually in pen and ink. Detailed studies followed (in various mediums, such as chalk), leading to the drawing of a life-sized cartoon of the composition. The composition was then transferred from the cartoon to the painting surface – either a wall or an easel panel.

Looking at *The Adoration of the Magi* is a useful way to sum up da Vinci's approach to composition. He made many drawings of horses, figures and buildings, and a study with perspective lines (page 44). But he abandoned this painting at an early stage. The underdrawing shows us his procedure and allows us to appreciate the importance of drawing in his paintings.

Leonardo da Vinci, Adoration of the Magi (c.1481). Painting. 246 x 243 cm. The Art Archive / Galleria degli Uffizi Florence

The Last Supper – a masterpiece of human expression

Da Vinci's *Last Supper* follows the traditional composition used by other artists of a long trestle table with figures seated at one side. However, he made changes to improve this static composition. The custom was to place Judas alone on the opposite side of the table – an awkward disruption to the structure of the whole. Da Vinci improves the compositional flow by placing Judas on the same side as the other figures. This adds to the drama of the moment when Christ announces that one among his followers will betray him.

Analysing the composition

The scene is based on two squares, as in da Vinci's earlier painting *The Annunciation* (the golden section being derived from the diagonal of two squares). Da Vinci combines symmetry with the golden section. Christ is in the centre. All vanishing lines lead to the vanishing point on the horizon line, on his face. The top of the windows lies at a golden section (as do the outer edges of the side windows). Christ's hands are at the golden section of half the height of the composition.

The composition abounds with satisfying repeated patterns. Our master uses the ingenious device of grouping the figures in threes, in a series of four cones, with Christ forming the fifth. Obvious rhythms are the repeated patterns in the wall panels, tablecloth folds and trestle legs. A striking example of pattern inversion is the right hand of Christ and the left hand of Judas. We see again the familiar use of a window framing the central figure and distant landscape. Da Vinci's application of the Fibonacci series (page 52) is evident – 1 table, 1 central figure, 2 side walls, 3 windows and figures grouped in threes, 5 groups of figures, 8 wall panels and 8 trestle legs, 13 individual figures. You can continue analysing; for example, only one wall is illuminated.

Perspective Lines and Golden Section in The Last Supper

There she is!

The smooth-chinned 'St John' sitting on Christ's right in *The Last Supper* has all the attributes of the female formula used by da Vinci — serene expression, downcast eyes, graceful turn of the head and self-composure. (It is the same head as da Vinci's *Leda* on page 79) The face is smooth and rounded from the thicker layer of fat beneath the skin, a feminine characteristic that da Vinci keenly observed. The facial features, bust line and hands are feminine. Is this Mary Magdelene? The pose and clothes of Christ and Magdalene are mirror images, forming a deep triangular space between them. This is the only 'disciple' with clasped hands; all the others are gesticulating. Da Vinci made a chalk study for the hands, but there are no studies for this head.

Da Vinci was not the only artist to include a woman in *The Last Supper*. We see one in Ghirlandaio's frescos, and in a relief sculpture based on da Vinci's painting attributed to Tullio Lombardo (*c.*1500), which shows a figure with breasts in the position of John next to Christ.

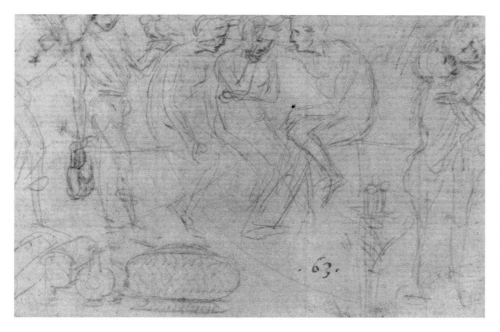

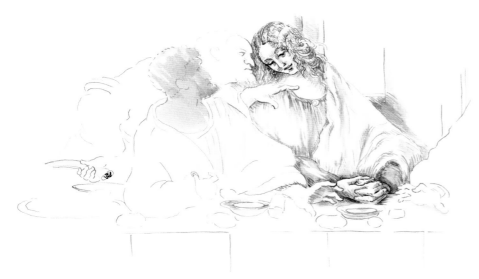

Leonardo da Vinci, Study of seated figures in conversation *(1480–82). Metalpoint on pink prepared paper. 85 x 125 mm. The Royal Collection © 2006 Her Majesty Queen Elizabeth II*

Da Vinci jots down flashes of nascent ideas for 'The Last Supper'. Notice the central figure, head cupped in hand, deep in thought, consoling companions either side. Is this Mary Magdalene? Da Vinci's sketches show various ideas as he develops the composition.

Magda-Leda *(2005). Brush, pen, two shades of ink. 21 x 30 cm. Based on da Vinci's 'The Last Supper' and 'Study for the head of Leda', c.1505-07*

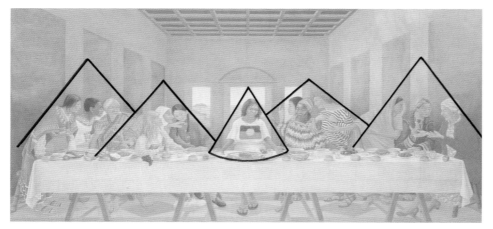

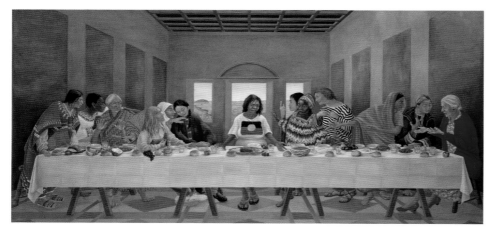

A Row of Tents – from The First Supper, 1988
(2005). Felt pen, giclée. 21 x 29 cm

This diagram shows da Vinci's innovative conical grouping device for the figures.

The First Supper (1988). Acrylic painting on panel.
130 x 250 cm. Mitzdorf Collection, Munich.

My Mate Molly: Study for The First Supper (1980).
Watercolour. 40 x 30 cm

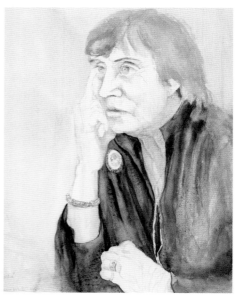

EXERCISE Converting *The Last Supper* to the First

Never lose sight of the fact that first and foremost, this is a drama of different facial expressions and hand gestures – a scene of communication among humans. Da Vinci's characters all have similar features, but communities today are made up of people from all over the world.

You will need a board, paper or canvas in the shape of two squares and your chosen media, along with a ruler and calculator.

1 Determine the centre by dividing your board with horizontal and vertical mid-lines. Continue to rule a grid of smaller squares.

2 With the aid of a calculator, scale the size and location of the various elements of the composition using a reproduction of *The Last Supper*.

3 Rule in vanishing lines for the wall panels, the ceiling and the floor tiles, to meet at the vanishing point.

4 In true da Vinci style, reverse everything! Turn the men with similar features into women from different regions of the world; change dark Judas to a blond; include a male (all the better if he is bald or bearded) next to the central figure. Invent your characters or make sketches from life.

5 Use the next number in the Fibonacci series to determine the number of feet, now mostly missing from the original.

6 Eat well! Choose an international spread of food for the table. If drawing a watermelon, make sure you finish it before it rots inside and explodes.

Drawing conclusions

Da Vinci did not sign his drawings, so we can never be absolutely certain of his authorship. Signing artwork was not a Renaissance custom, and drawings were not even considered works of art in their own right.

EXERCISE 1 **Finding faults**

This exercise examines an awkward drawing (Figure A) by da Vinci's student, who has attempted to add a head to the master's graceful drawing of shoulders and neck for the *Yarnwinder Madonna* (inset in Figure B).

1 The drawing in Figure A looks out of proportion. The perspective is wrong, particularly at the eyes. The vanishing lines through eyebrow crests, eye-corners and mouth-corners are haywire, and do not converge at a vanishing point. The inner corner of the right eye is too high and on the wrong plane. This gives the subject the devious look of a yarn spinner.

2 Notice that the far eye is as heavily drawn as the nearer eye. This results in flattening of the face by bringing its far side to the fore.

3 The chin, far cheek and shoulder outlines are heavy and stiffly drawn. The junction of the left shoulder and cheek is abrupt.

4 The shoulder in the foreground is too small and flat. The shading is in the wrong place. The line of the garment continues in an upward arc instead of changing direction in a curve with the planes of the shoulder.

5 Observe that the scoop of the garment neckline is at the wrong angle, giving the body an unnatural twist. This is because the neckline lies at the same distance from each shoulder – the vanishing lines of the shoulders and the neckline are parallel,

making the proportions the same on the far and near side.

6 The proportions of the upper chest are peculiar. An impossibly high cleavage emerges just below the collarbone.

Fixing faults

To fix the faults, use Figure B as a guide. Adjust the positions of the facial features so that the vanishing lines fan out regularly from a vanishing point. Lower the near eye to sit in the eye-socket. Enlarge the near shoulder considerably, and improve the direction of the curve of the neckline where it passes over the shoulder.

Figure A

Figure B

FIGURE A Faulty Perspective; With Inset of 'Study for the Yarnwinder Madonna' by Cesare da Sesto (?), Da Vinci's student, *c.*1500 *(2005). Biro on giclée. 29.7 x 21 cm*

FIGURE B Correcting a Student's Yarn Spinner; With Inset of Da Vinci's 'Study of the bust of a woman' (for the Yarnwinder Madonna), *c.*1499–1501 *(2005). Conté and pencil on giclée. 29.7 x 21 cm*

EXERCISE 2 **Your turn to transplant a head**

Now that you can draw like da Vinci, you can modify his drawing *Study of the bust of a woman (Yarnwinder Madonna)* to create a portrait in your own style. You will need earth-red and white conté or pastel pencils.

1 Download and print a very pale version of the *Study of the bust of a woman* on archival art paper.

2 Have your live model adopt the same pose and turn of head as in the da Vinci drawing. Observe the fundamental feature of the twist of the head and the body, so that the left shoulder and the right eye are closer to you. This is the essence of the grace and beauty of the movement.

3 Apply your new knowledge of drawing faces in perspective and proportion.

4 When drawing the clothing, it should follow the shape of the model's body and fall naturally.

You, the connoisseur

Equipped with your newly acquired understanding, you can now detect a faulty three-quarter view portrait in an exhibition. Hold your catalogue up and align its edge with the eyebrow ridge, the eyes and then the corners of the mouth. If the catalogue does not rotate evenly in the one direction, but has to be tilted back and forth, then you know that the perspective is out and that it is not a da Vinci!

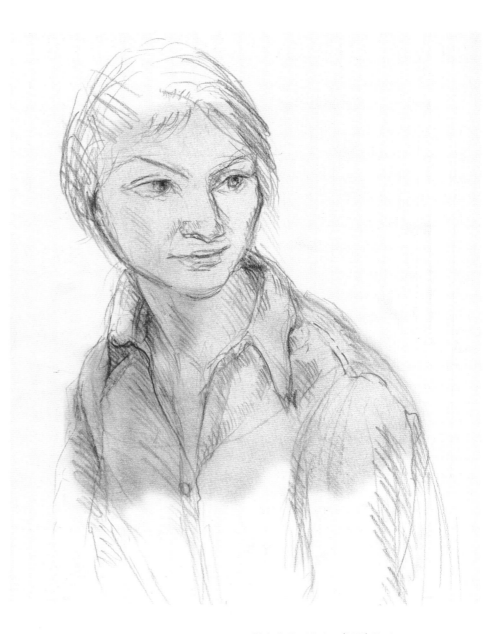

Pink-Collar Worker *(2005). Earth-red and white conté over giclée. 29.7 x 21 cm. Based on Da Vinci's 'Study of the bust of a woman' (for the Yarnwinder Madonna), c.1499–1501*

Virgin uncovered after 400 years in hiding

Recent infrared illumination of the London version of *The Virgin of the Rocks* revealed a drawing underneath of a completely different composition. The figure has an outstretched right arm, with the left arm folded in, hand at breast, in a similar gesture to St Jerome in da Vinci's unfinished painting.

Was this drawing da Vinci's actual intended composition? Did he really paint a second version of *The Virgin of the Rocks*?

Imagine the halo on the London angel as the rim of a hat, and you see that it would sit askew on the infant's head – a slouch halo!

The sfumato of the London painting is harsh. The tones are unbalanced, with awkward contrasts. Da Vinci's skill with aerial perspective is lacking, so that parts of the background leap forward unnaturally.

It is uncharacteristic for da Vinci to include a cross in his work. Was this added later?

The most telling clue is the angel's gaze, which is in the opposite direction to the movement of the head; this is not da Vinci. The angel's eyes are looking in the wrong direction for the movement, giving it a sly expression, quite unangelic! In the Paris version, the angel's gaze follows the natural movement of the head and looks directly at you, drawing you into the scene. The angel's finger points to the infant at the focus of the composition. This crucial characteristic of da Vinci's pointing hand is missing from the London version.

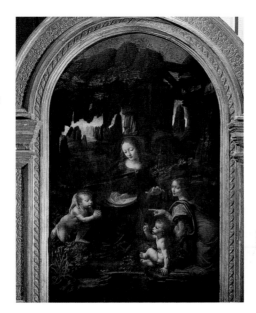

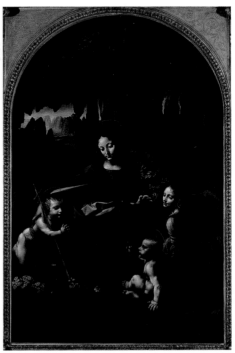

Infrared Conjecture: Completing the Drawing Underneath the Virgin of the Rocks *(2005)*. *Black and white chalk, ink, giclée. 29 x 21 cm*

Leonardo da Vinci, The Virgin of the Rocks *(c.1483–86). Painting. 1980 x 1230 mm. The Art Archive / Musée du Louvre Paris / Dagli Orti*

Leonardo da Vinci, The Virgin of the Rocks *(c.1495–1508). Painting. 1895 x 1200 mm. The Art Archive / National Gallery London / Eileen Tweedy*

Myth-conceptions and myth-interpretations

Misunderstanding da Vinci can lead to wrong conclusions. For example, his sketches for a human robot are sometimes misinterpreted as inferior anatomical drawings because of their stiff mechanical parts – in fact, they are da Vinci's design for Frankenstein hundreds of years ahead of time. Our master would see through Doctor Who!

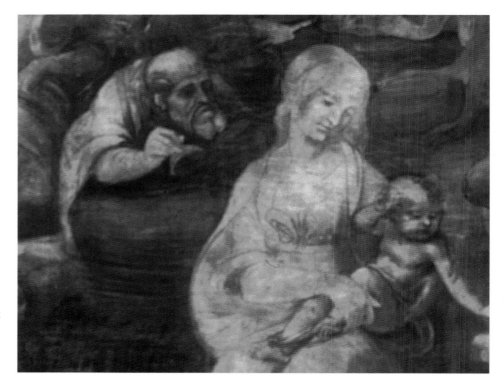

Leonardo da Vinci, Adoration of the Magi; *detail (see page 130)*

Re-interpreting a da Vinci sketch

The drawing that is reputed to be the first sketch of Peter for *The Last Supper* looks nothing like the figure of Peter in the painting. However, the drawing has a remarkable resemblance to the figure on the Virgin's right in *The Adoration of the Magi*. It has the same forward-leaning movement and hand-pointing gesture. The association of this drawing with *The Last Supper* seems to be a myth.

De-bunking the optical aid myth

We have explored how no camera or optical aid can replace visual literacy, such as perspective. It is absurd to suggest that da Vinci lacked the imagination and intellect to draw accurately. To conceive his bird's eye view landscapes in perspective, did he suspend himself above the clouds in a little black camera obscura tent, or set up a perspectograph in the heavens?

Artists such as Canaletto, who lacked the imagination and skill to depict movement, sat inside such a black camera to copy a static 'photographic' image a century after da Vinci's time. There are artists today who use photographic images in a similar way. Realism that relies on optics or photographs without knowledge of the discipline of drawing produces inferior art.

Forging da Vinci convincingly

Anyone thinking of forging a da Vinci would need to consider the following: Locating a paper made in the fourteenth or fifteenth century is difficult, and faking aged silverpoint is troublesome. Mixing an authentic toned ground is not easy; grinding the lead base and extracting pigment from lapis lazuli for a blue ground is laborious.

Ink drawing poses problems too. Making a mixture of authentic iron gall ink is simple enough – grinding the gall and mixing it with gum and water and a little wine – but

the aging process to change it from black to brown takes years.

If you want to try your hand, acknowledge your forgery from the start. Copy a da Vinci sketch and draw the same image back to front, making a few subtle changes. Remember to draw left-handed hatching lines. A convincing idea is to make a drawing from part of a painting by da Vinci.

It is time now to start doing your own thing and to stop being a copycat. Have a drawing good time!

In these I have not been hindered by avarice or negligence, but only by want of time. Farewell.

That's not my Bicycle! (2005). Black and blue ballpoint, sepia ink and wash, pencil underdrawing. 29.7 x 21 cm

The bicycle drawing copied here was once claimed to be a da Vinci. It bears no comparison with his masterful drawings of gears, engines and machinery.

Leonardo da Vinci, 'Farewell' – from Studies for a Madonna with a cat *(see page 31)*

Glossary

AERIAL PERSPECTIVE Shapes becoming bluer, paler and less distinct as they recede in the distance.

ANGHIARI Battle in 1440; subject of painting by da Vinci.

ANNEALED Where wire has been heated to remove stresses.

ARMILLARY SPHERE Sphere of hoops or rings representing celestial orbits.

ARNO River through Florence which flooded in 1466 and 1478; big impact on da Vinci.

BICEPS Two-headed muscle at upper part of arm that flexes and supinates the forearm at the elbow.

CAMERA OBSCURA Small dark room or box that receives images of the external world through a pinhole or small lens.

CANALETTO (1697–1768) Venetian painter of topographical scenes.

CARAVAGGIO (1573–1610) Italian artist who used rich colours and accentuated shadows. Painted directly on canvas.

CENNINI, CENNINO (c.1370–c.1440) Italian artist; author of Libro dell'arte (the craftsman's handbook).

CESARE BORGIA (1475–1507) Son of Pope Alexander VI; brother of Lucrecia. Employed da Vinci as a military engineer in 1502–03.

CHIAROSCURO Treatment of light and shade in an image.

CHINESE WHITE Trade name for water-based paint of zinc oxide and gum arabic.

CLUTCH PENCIL Drawing device with a mechanism that locks or allows a pencil lead or stylus to extend or retract.

CODEX Classical volume or manuscript. The *Codex Atlanticus* consists of 12 volumes of da Vinci drawings. Two more volumes of his drawings comprise the Madrid codices.

CONTÉ Common and trade name for crayon, invented by Nicolas-Jacques Conté in 1795.

DIVINE PROPORTION Term used to describe the golden ratio during the Renaissance; title of book by Luca Pacioli.

DEXTROUS Right-handed.

DISSECTION Separation of body structures by cutting and traction.

DRAFTING PEN Fountain pen with metal cylindrical nib and central fine wire stylus. Makes an unvarying line.

EXPLODED VIEW Drawing of a structure's components, separated as if by an 'explosion' and connected by lines.

FEATHERING Technique of blending adjacent colours by interweaving.

FIBULA Thin bone beside the tibia.

FORMALDEHYDE Chemical constituent of preservative solution for anatomical specimens.

FRESCO Italian for 'fresh'. Painting on wet lime plaster so pigments are absorbed into plaster.

GESSO Plaster of calcium sulphate obtained after roasting gypsum or alabaster. Applied in layers to a wooden panel as a ground for painting and metalpoint.

GHIRLANDAIO, DOMENICO (1448–94) Italian painter in fresco; workshop in Florence where Michelangelo trained.

GICLÉE From the French for 'spray' or 'squirt'; digital printing with archival inks on archival paper.

GOUACHE Opaque watercolour paint.

GROUND Prepared pigmented surface applied by brush to paper or board for metalpoint, chalk or pastel drawing, or for painting.

HATCHING Use of closely spaced parallel lines to create shading.

HEIGHTENING Increasing lightness of an area of a drawing with white (or pale colour) to render form.

HELIX Spiral or coiled form, usually advancing around an axis like a corkscrew.

HIGHLIGHT Area on a surface that reflects much light.

IL CAVALLO Italian for 'The Horse', da Vinci's monumental equestrian monument which was never completed. The bronze was used to make weapons instead.

INFRARED REFLECTOGRAPHY Artwork is illuminated by infrared light and photographed to reveal underdrawing.

IRON GALL INK Indelible ink made from galls (nut-like growths on trees), iron sulphate, gum, wine and water.

LA GIOCONDA Italian nickname for the Florentine Mona Lisa who allegedly married Francesco del Giocondo in 1495.

LEAD White lead pigment (now termed 'flake white') used by Renaissance artists for paint and prepared grounds.

LAPIS LAZULI Latin for 'blue stone'. Deep blue gemstone introduced to Europe by Alexander the Great as ultramarine ('beyond the sea'). Ultramarine blue pigment was extracted from pulverised lapis lazuli.

LEDA AND THE SWAN Da Vinci painting, lost a century ago due to deterioration.

LILLI PILLI Common eastern Australian tree with small crisp, fleshy edible fruit.

LITHOGRAPHIC CRAYON Crayon used for drawing on stone or metal plate at the initial stage of lithography, for producing limited edition prints by direct hand printing.

LUMEN CINEREUM Latin for ash-coloured light; lustre of the new moon discovered by da Vinci and interpreted as the moon being surrounded by its own 'atmospheric elements'.

METALPOINT Name applied both to drawing with a metal stylus and the actual drawing.

MIXED MEDIA Different techniques in one artwork.

MONOCHROME Single-coloured.

ORNITOTERO Machine like a bird.

PACIOLI, LUCA (1445-1517) Mathematician; close friend of da Vinci.

PATINATION Oxidisation of metal surface, resulting in a coloured film or encrustation.

PERSPECTOGRAPH Instrument with glass pane and gridlines to allow an observer to transfer an object to a surface in its proper perspective and proportions.

PLASTINATION Technique invented in 1977 for making permanent dry anatomical specimens, by embalming, dehydrating and impregnating with polymer plastics.

PIGMENT Particles of colour for making paint, pastels etc.

POLYHEDRON Three-dimensional shape of many faces.

POUNCE Fine pulverised charcoal or lead white in a (pouncing) bag; used for dusting pigment on to a light or dark surface; see SPOLVERO.

PROPORTION Relation between four quantities where the ratio of the first divided by the second is equal to the ratio of the third divided by the fourth; any one quantity is immediately specified by the other three. Therefore any three numbers determine a proportion.

PROSECTOR Anatomical dissector.

QUILL Pen made by cutting and shaping a goose feather tempered in hot sand.

REFLECTED LIGHT Light reflected onto a surface in the shadow of the main light source.

RENAISSANCE Rebirth; a metaphor applied to the revival of ancient Greek culture in arts, letters and learning in Europe from fourteenth to sixteenth centuries.

SALA DELLE ASSE Room in tower of Sforza Castle where Leonardo painted a fresco of interweaving willow trees; c.1496–98.

SALVATOR MUNDI Latin for 'Saviour of the world'.

SCADENZA Italian for 'expiry'.

SEPIA Dark brown tone pigment mixture.

SFORZA, LUDOVICO (1452-1508) Member of Sforza dynasty of Milan. Hired da Vinci as court painter and engineer.

SFUMATO Transition of tone from light to dark by imperceptible stages.

SHELLAC Varnish used in traditional water-soluble ink.

SINISTROUS Left-handed.

SPOLVERO Contours of cartoon pin-pricked with holes through which pigment is dusted on to a painting surface.

ST JEROME (c.340-420) Scholar. Subject of unfinished painting by da Vinci.

STAR OF BETHLEHEM PLANT Poisonous plant with white star-shaped flowers.

TEMPERED Made tougher and more pliable by heat.

TERRE VERTE Earth green pigment from volcanic minerals. Varying tones from bluish green to olive green.

TIBIA Shin bone.

TOOTH Fine texture of any dry surface, such as a ground, which makes it abrasive and receptive to metalpoint.

ULNA Longer of the two bones of the forearm which projects at the point of the elbow.

UNDERDRAWING Initial roughing out for a drawing, or precise marking of contours for a painting before applying opaque pigments.

VENETIAN GLASS PEN Glass dipping pen for fine lines.

VERROCCHIO, ANDREA DEL (1435-88) Florentine goldsmith, painter and sculptor. Master of workshop in Florence, where da Vinci worked for 12–13 years.

VESALIUS, ANDREAS (1514-64) Physician and anatomist. Author in 1543 of De Humani Corporis Fabrica (on the fabric of the human body), illustrated by unknown artist.

VINCI Hilltop town of wstern Tuscany, close to Florence.

VITRUVIUS Roman engineer, architect and codifier of architectural practice; active in 1st century BC.

VORTEX Whirling mass of air or water.

YARNWINDER MADONNA Painting by da Vinci, 1501. Original lost; copies exist.

Index

Note: Titles of books and pictures are given in italics. Those by da Vinci are listed under his name.